Julian Spalding

The Eclipse of Art

Tackling the Crisis in Art Today

Prestel

Munich · Berlin · London · New York

Prestel-Verlag
Königinstr. 9
D-80539 Munich
Tel.: (89) 38-17-09-0
Fax.: (89) 38-17-09-35
www.prestel.de

Prestel Publishing Ltd.
4 Bloomsbury Place
London
WC1A 2QA
Tel.: (020) 7323 5004
Fax.: (020) 7636 8004

Prestel Publishing
175 Fifth Avenue, Suite 402
New York
NY 10010
Tel.: (212) 995 2720
Fax.: (212) 995 2733
www.prestel.com

Library of Congress Control Number: 2002116866

Prestel books are available worldwide. Please contact your nearest bookseller or any of
the above addresses for information concerning your local distributor.

Editorial direction: Philippa Hurd
Typesetting and Origination: Saffron Page Ltd., Norwich, Norfolk
Printing and binding: Graspo, Zlín

Printed in the Czech Republic

ISBN: 3-7913-2881-6

Contents

Preface

This book is based on forty years of looking at and thinking about modern art. I have my late parents to thank for having books on van Gogh and Picasso at home, and I am indebted to countless numbers of people in the decades since then, colleagues and friends in the art world — both those I agreed with and those I disagreed with — whom I met and worked with during the thirty years I spent as a gallery curator and director. Much of this book is based on my personal memories of these times, but I would especially like to thank a few friends and colleagues, Eileen Adams, Ken Baynes, Patrick Davies, George Donald, Pat Gibberd, Peter Green, George Kerevan, Fiona Robertson, Sandy Moffat, Paul Waplington and Jess Wilder, whom I questioned closely about specific aspects of this book, particularly those on art education and dealing, to make sure that my views were not awry. I would like to thank the staff in Edinburgh City's Libraries' splendid Fine Art Department and those in the library of the Scottish National Gallery of Modern Art, who helped me find so many of the books and catalogues that I needed to trigger my memory and check my facts.

During all those years of looking at art, I increasingly began to find myself fighting a battle for the heart of the fine arts which I thought none of the modern masters ever meant to jettison. I wondered if this was just age creeping on — everyone's judgement is, to some degree, skewed by the vivid experiences of his or her youth — but I was still able to be impressed by the art of the young. It was just that I found less and less of it interesting. It was not that I did not understand the new art as it came along; rather the reverse, I understood it all too easily. So much of it seemed to me to be just weak repetitions of what had gone before. Slowly it began to dawn on me that I might have a point to make. I have to thank all those close to me, and especially my wife Gillian, who have supported me while I dug into what has been, at times, dispiriting terrain. I must thank my editor, Philippa Hurd, who helped me crystallise my thoughts and, finally, my warmest thanks go to my friend and literary agent, Louise Greenberg, who insisted that I write this book; and, in the end, I am glad she did.

Finally, a word on illustrations. It is becoming increasingly difficult today to get permission to illustrate art you want to criticise. Copyright is automatically awarded to the artist: this ensures the artist's economic rights so that artists do not lose out on any royalties that their works might earn. However, in the last two decades, copyright has been extended to cover the artist's moral rights; i.e. the right of artists to ensure that their works are exhibited and reproduced in circumstances that are respectful to that work. Artists now have the right to resist any intervention that comes between their work and their public. This is just insofar as it enables artists to prevent their work being displayed upside down, or hung at an angle as happened in the Nazis' Degenerate Art exhibition in 1937. But artists are now beginning to use this right to object to the art displayed alongside theirs in public galleries, thereby limiting the opportunities for critical comparison. And, increasingly, artists and their dealers decline to give permission for the reproduction of works in texts that are critical of those works. This is one reason why there has been a noted decline in serious, critical analysis of contemporary art.

Julian Spalding
Edinburgh, February 2003

Why you are right not to like modern art

This book has been written for people who, though they enjoy art in general, have become confused and disenchanted by the art of our times. It has been written for those who feel sure they can respond to art and want to remain open-minded, but can see very little merit in what is being promoted as art today. It has been written, above all, for those who know they have a right to their opinions but no longer feel they have the right to express them. The aim of this book is to give people back the power to make up their own minds about what is good and bad in modern art, together with the ammunition to back those judgements up. It argues that until the public for art reclaims its right to applaud and condemn, the art of our age will remain in the dark, the self-indulgent plaything of a few.

I have never met anyone who told me they *loved* modern art. No one ever came up to me, their eyes glowing with pleasure, telling me I just *must* see, say, the new wall drawings by Sol Lewitt in the 1970s, or the smashed plate paintings by Julian Schnabel in the 1980s, or the life-size, glazed porcelain figures by Jeff Koons in the 1990s. I do remember being enthusiastically encouraged to see the 1960s' shows by American Abstract Expressionists such as Pollock with his famous drip pictures, and Rothko with his hanging veils of luminous colours. But already there were caveats: they were worth seeing, though some doubted where they were going. Even then many sensed that art could be heading into a cul-de-sac. Never, in all these years of attending modern art exhibitions, have I been greeted with that full-hearted exhortation that I just *had* to see such-and-such an exhibition as if it were showing the work of a new Picasso or a Matisse, or to lower one's sights, the next Henry Moore or Raoul Dufy. All these were unquestionably artists in the fullest sense of that word — they celebrated our existence by making us more conscious of it. They each merit that magical name 'artist', and we can love the best work by each of them to different degrees. But love is not a word that springs to mind when one thinks of much modern art — so much so that one wonders whether it is art at all.

I have, however, met plenty of people who have told me that I *ought* to like modern art; though, I have to admit, none has ever gone so far as to say that I ought to *love* it. There is some place for 'ought' in life, but none at all in art; art is a gift, not a duty. The people who told me that it was my job as a curator to like modern art invariably had a vested interest in so doing; they all earned their living either making or selling, teaching, criticising or curating modern art. Outside that coterie, practically no one has ever urged me to like modern art, apart from some people in the worlds of the media and marketing. The latter like modern art because they genuinely admire anything that can attract so much attention. It *has* to be a good thing simply because of that. They never need to look at it closely, or form an opinion for themselves. That has been done for them. So the advertising agencies incorporate modern art into beer labels and TV commercials, fashion accessories and restaurants, though why anyone would want to eat dinner facing the decapitated, putrefying head of a cow is beyond my comprehension. The vast publicity this new art has attracted has brought in its wake a wave of media well-wishers.

I intend to counter all these arguments by focussing on what art is actually about — on its meaning, not on its promotion, nor even its packaging. Content cannot exist without form, and obviously, marketing influences that form, as it influences everything to which we want to attract attention. The crucial question is: how good is the content? If we take our eye off that for a second, we are in danger of being distracted by the wrapping. Unbelievable as it might seem to those unfamiliar with the world of modern art, the self-styled artist Piero Manzoni canned, labelled, exhibited and sold his own shit (90 tins of it) in the early 1960s. The Tate has recently acquired no. 68 of this canned edition, for the sum of £22,300. They have coyly catalogued it as a 'tin can with paper wrapping with unidentified contents'. None of those who collected Manzoni's tins has, as far as I know, tested the veracity of their contents, but then, who would want to? In another work, Manzoni drew a line on a strip of paper — a single, long line, in ink — rolled it up, put it in a tube, sealed it, and recorded the length of the line and the date of its making on a label pasted to the outside of the tube. The idea was that these tubes, containing lines of different lengths, should remain unopened. This takes the triumph of wrapping over content to its

logical, but sterile, conclusion. How can a line you cannot see be art? Nevertheless the Tate gallery has *two* of these tubes in its collection. It is all too obvious to anyone not in the art world (though this is always denied by those within it) that a rift has opened between the art being promoted in contemporary galleries and the art people like to hang on their walls at home.

There would not be much point in writing this book if there were nothing wrong with modern art. That, however, despite all the public's outrage and disbelief, is the official position. Sir Nicholas Serota, the current Director of the Tate, and others, argue that art has always had its radical elements and that new generations produce the art that interests them. That, it is said, inevitably upsets the older generation, which is all that is happening now. They maintain that experimentation is uppermost at present because young artists are expressing themselves through modern technology such as videos and computers, which people used to the traditional languages of art, such as painting and sculpture, find disturbing and difficult to comprehend. They say that the traditional arts will be back. It is just a swing of the pendulum within the wonderful richness of art. There is a time for adventure and a time for consolidation. That is all; end of story. But there is another way of looking at the recent history of modern art, which sees it not as an exciting, creative scene but as one in terminal decline. The evidence for this is staring us in the face: where is our new Picasso or Matisse of 'conceptual art'? Every age has had its great artists, and many less great besides, but where are ours? Do we really want to be remembered for a shark in a tank of formaldehyde? If the pendulum is the right analogy, then what we are watching is not the one on the clock but the one in Edgar Allan Poe's pit, with art at the bottom being slowly but surely hacked to bits.

When you start talking about art being in decline, people immediately ask you what you mean by art. Of course there is no easy definition of art. In *The Story of Art*, E.H. Gombrich wrote that there was no such thing as art, only artists. In a key sense, this is true. How can the passionate agony of Michelangelo, the serene grace of Raphael and the intense questioning of Leonardo all be embraced by the term 'art'? It is difficult to think of three more different artists, even though they were broadly contemporary and

11

all knew each other's work. Their art only makes sense when one considers what they were trying to communicate about their own, highly divergent experiences and visions of life. What they have in common is the language they used to convey the content of these experiences, and that is where art comes in. Art is essentially a means of visual communication, though that does not mean to say that all visual communications are works of art. To qualify for such an elevated status they must convey content of lasting value. Street signs and maps, comics and advertisements are not art, though you will find many masquerading as such in the art galleries of today. We reserve the word 'art' for those rare visual creations that stir our emotions and stimulate our thoughts profoundly and elusively, which we find difficult to express through other means, but which we nevertheless feel to be true to our experiences. As such, this definition adequately, if mundanely, embraces the sensations we get from looking at a Matisse or a Picasso, even though the experiences these two artists communicate are as different from each other as Raphael's was from Michelangelo's. We can look at both, however, and judge each to be in its own way true. Art, in the end, is not an illusion but a revelation. The more profoundly it reveals the nature of our existence, the greater art it is. Those accepting such a definition must be discontented with most of the art they see in public galleries today.

We are assured again and again it is just a swing of the pendulum. You might not personally like what you see today, but you will like what you see tomorrow. The modern art world in the late 1960s and early 1970s was dominated by a wave of minimalist, conceptual art, epitomised by the 'bricks', as Carl Andre's *Equivalent VIII* was popularly called when the Tate Gallery bought it in 1972. This was a low stack of stock-bought firebricks presented as a work of art. By the late 1970s, many felt that this vein of art had run out of steam and that it was time for the pendulum to swing back. So, in 1981, a major exhibition appeared at the Royal Academy in London called *A New Spirit in Painting*. The organisers (Norman Rosenthal, the exhibitions officer at the Academy, Christos M. Joachimedes, a German art historian and Nicholas Serota, then director of the Whitechapel Art Gallery in London) stated in the catalogue: 'We are in a period when it seems to many people that painting has lost its relevance as one of the

highest and most eloquent forms of artistic expression. It is argued that it has become academic and repetitive and it has the capacity neither for technical mastery nor for originality. It seems to speak to neither artists nor to a wide audience'. But, they continued, all was not lost: indeed 'Great painting is being produced today'. So they hoped that their exhibition would 'regain for painting that wide audience which it has always claimed but which it has recently lost'. Unfortunately the exhibition did not, quite simply because there was no great painting in it.

Apart from a few tail-end minimal paintings, the exhibits were all remarkably similar, as if all the artists had been programmed with a single agenda: almost all of them worked on a huge scale with large sweeping brushstrokes, some of which vaguely adumbrated figurative forms hinting at personal, cryptic mythologies. One left the show feeling as though one had been swimming through a wide, sluggish river of sloppy paint spread across acres of canvas in which were floating iconic images of skulls or torsos, Egyptian gods or Native American Indians, half-emerging from or sinking back into the general muddy drift. It was difficult to remember the contributions of individual artists, or, indeed, locate any genuine personal experience in the swell. I had gone to see the exhibition with enthusiasm but left feeling I had been bamboozled.

I first began to sense that something had gone fundamentally wrong with art when I went to see an exhibition of 20th-century German painting and sculpture at the Royal Academy in London in 1985. The show was a revelation, but not in a manner that the organisers could ever have intended, nor anyone else have predicted. The exhibition was hung chronologically from 1905 to 1985, except that all art from the Nazi period and from East Germany under communist rule had been excluded, on the grounds that it was propaganda. Up until the works from the 1930s, the crowds of visitors all edged their way along, shoulder to shoulder, moving slowly, studying each picture and sculpture in turn. In the post-war galleries, the visitors' behaviour changed: they were not lining the walls any more, but were wandering from one picture or sculpture to another, at random, according to what caught their eye across the room. The compunction to see everything in turn was gone, and few stayed for long to look at any single work. The visitors had become disengaged, and they remained so

for the rest of the show. This change of behaviour was so marked that I walked back through the exhibition three or four times just to observe it.

I am not saying that the inclusion of official paintings and sculptures of the Nazis and the German Democratic Republic would have sustained the attractiveness of the show, but at least visitors would have been able to see what the artists in post-war West Germany were reacting against. Anselm Kiefer was born in 1945, and Germany's horrific past hangs heavily over his huge canvases. He painted once-golden cornfields now blackened by burning. They were, consciously, the other side of the coin to the Nazis' saccharine images of golden-haired earth mothers and golden-haired offspring. The meaning of Kiefer's paintings can only be fully grasped if one knows about the imagery that came before them.

Just a few Nazi and communist works included in the Royal Academy exhibition could have enabled visitors to make these comparisons and judge for themselves how bad this art actually was. To dismiss all of it as propaganda is propaganda in itself. All art worth the name, to some degree, directs the viewer's thinking, but are they lesser works of art for doing so? Art can have allegiances and still be great: the power of Michelangelo's *Last Judgement* is not diminished because it warns us to be good. Post-war art in general, in both the West and East, *was* restricted by ideology. Kiefer's paintings were as much an expression of the accepted mores of western culture at that time as the Socialist Realist paintings were of the culture of the Soviet bloc. That was why the public became so dramatically disengaged in the middle of the Royal Academy's survey of 20th-century German art.

Great artists of the past had an easier job attracting the attention of the public. They enjoyed, for centuries, a virtual monopoly on visual imagery. They were like film directors, advertising magnates, designers, illustrators, decorators and architects rolled into one. Since the invention of films and television, photographs and colour printing, computers and DVDs, the artist's share of the visual market has diminished considerably. Today, they are only valued as artists. But one only has to see the queues forming to see a show of paintings by Dalí or Matisse, both of whom operated in this context, to know that there is still a hunger for the created image. It is not the need for art that has diminished, but the quality of art that is being shown. This is not because it is no longer being made, as I will try to show

14

towards the end of this book. It is because a benighted view of art has a stranglehold on the few who choose what little art we are allowed to see. And the public acquiesce, because what else can they compare it with? Even if they could make such comparisons and choose the art they wanted to look at, what would be the point when they have been told, again and again, that their opinions are invalid? There is a Catch-22 situation here. The advocates of modern art cannot have it both ways: they cannot expect people to be put off by modern art and like it at the same time. Modern art, by definition, is supposed to offend the public, so, one could argue, people are right to be offended by it. If modern art is really no good, then people are also right to be offended by it. So, whichever way you look at it, the public are right not to like modern art. This book aims to break through this impasse.

In 1999, I journeyed to Cornwall to see an eclipse of the sun, for the first time, on the line of totality. The sky was overcast in the morning, and it began to rain as the time for the eclipse approached. Still, at 9.30, we all trudged up the nearby hill, hoping that by some miracle the clouds would part. At the onset of the eclipse, at 9.56, it became gloomier still. Soon it was so dark that the few birds that had been singing fell silent and the cows, lying in a nearby field, stood up and started to file home. Then the streetlights came on in a distant town and I shivered at the sudden, unnerving drop in temperature. It was dark only where we stood. A sliver of daylight could be seen along the distant horizon to the north, south and east. As I turned to look west, an even deeper darkness was beginning to rise slowly but perceptibly over the edge of the earth towards me. It grew larger and larger until it became a tidal wave of impenetrable blackness. It was frightening even though I knew what caused it. If you did not, it could only have spelt the end of the world. At 11.12, it engulfed us. A minute later, the darkness passed over us like the shadow of a huge bird of prey, with its wings spread wide across the earth. Suddenly I had my analogy. Art was not suffering from a swing of the pendulum, but was benighted by a total eclipse. This book charts the stages by which the constituents of art — its language, its teaching methods, its content and its judgement — have been eclipsed, one after the other, till there is virtually nothing left that is recognisable as art at all.

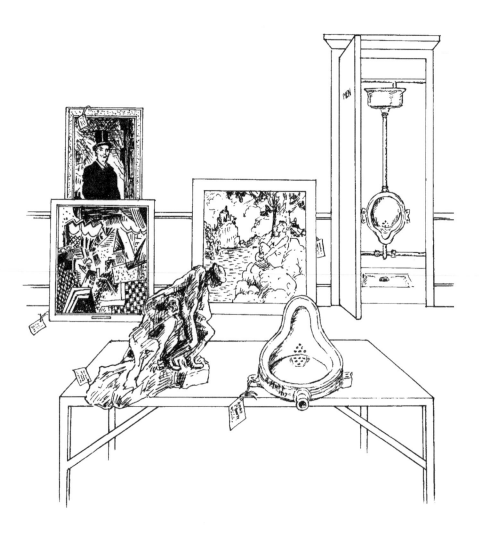

An imaginative reconstruction of the send-in day for the Society of
Independent Artists Exhibition, New York, 1907, with Duchamp's
submission surrounded by works typical of the period, with
a view through to the gentlemen's lavatory, showing a
urinal installed in its correct position.

The Eclipse of Language

In New York in the 1940s, painting still enjoyed unquestioned pre-eminence within the visual arts. So far has its status fallen today, that it now seems odd to read the passionate debates about it that filled the columns, letter pages and editorials of the newspapers, radio air-time and the new television channels, all over coloured pigments suspended in oil spread across canvas. New York then was packed with countless numbers of aspirant artists, working in lofts, all hoping against hope to be recognised. What made it interesting, however, was that, unlike the art scene of today, it was still possible for someone to win through on the grounds of sheer ability. Then, museum directors and curators as eminent as those from the Museum of Modern Art in New York, actually toured the studios of unknown artists, and in their wake collectors, dealers and critics followed. Though the griping and in-fighting was fierce as in any such scene, there does seem to have been a genuine feeling shared by most at that time that they were all taking part in a really important activity — to further the cause of art, and that meant, then, the art of painting. All eyes were on it at that historical moment, within the art world, among businessmen and, increasingly, politicians and even the wider public too. Not just the future of art, but also that of America and the world, seemed to hang on how and why paint was put on. It was a concentration of attention that was at once stimulating, but also damaging to art. To understand how the language of painting was first called into question we need to go back a little further in time.

The onset of the eclipse of art can be dated precisely. On 19 July 1937 queues started to form at the entrance to the exhibition of *Entartete Kunst* in Munich (*entartete Kunst* is usually translated as Degenerate Art, but the adjective *entartet* has racist overtones that are untranslatable in English). It still comes as a shock to learn that, in this exhibition, photographs of people with physical disabilities were hung beside Cubist and Expressionist masterpieces of modern art. The 730 exhibits, gathered from museums

around Germany, were hung on tacky screens in jumbled groups under banner captions that read 'Mockery of German Womanhood' or 'Complete Madness'. One screen was painted with a fake Kandinsky and pictures by Schwitters and Klee were hung against it at rakish angles. This was supposed to be an attack on Dada, though only Schwitters can be associated, and then only loosely, with that movement. The labels throughout the exhibition stated the name of the artist, the date of the painting, the region of Germany where it had been produced, the name of the museum that had purchased it and the price they had paid — a final masterstroke to provoke mass outrage. And the masses came: 2,009,899 visited the Degenerate Art exhibition in Munich alone between 19 July and 30 November 1937, which must make it the most popular show of modern art ever held. They certainly did not all come to pay their last respects to the art they loved: many came to mock and feel nervously superior, much as people used to laugh at public hangings. The dutiful ones among them, in considerably fewer numbers, then trooped round to see the Great German Art exhibition, hanging in the hall next door, showing paintings of golden-haired and rosy-cheeked families working together shoulder to shoulder for the Fatherland, and statues of naked youths unsheathing their swords 'in readiness', all beautifully displayed in a pristine white, spacious gallery.

How much the Nazis believed in the effectiveness of using art as positive propaganda, is questionable. There is evidence to suggest that Goebbels, the architect of both these 'good' and 'bad' modern art shows, though well aware of the value of promoting and justifying feelings of hatred among the majority, was unsure of the potential of using culture as a positive propaganda tool to encourage 'correct' behaviour. In any case he was not at all certain, what 'good' art should be. Some Nazi artists wanted the Third Reich to develop their own art of the future, based on Expressionism — after all, the Fascists in Italy had espoused Futurism. In 1933 Mussolini, who used his own image as a key element in his propaganda, personally endorsed a life-size portrait sculpture of his head by Renato Bertelli as a reproduction to be sold. It showed his distinctive profile rotated through 360 degrees, like a spinning top, all-seeing but without any eyes — the perfect symbol of a Fascist dictator. A faction of

artists in Germany, however, looked on all such modernist experiments with suspicion. They wanted a return to strict academicism, and a denial of all modern trends.

It is possibly not an exaggeration to say that if Hitler had not himself had artistic aspirations the fate of modern art might have been quite different. Hitler's adolescent townscapes are highly detailed, but purely mechanical exercises in representation. They exhibit some technical ability and determination, but little feeling and no love. When in power, Hitler wreaked revenge on all those whom he considered had blighted this ambition — those art teachers and all like them who considered that technical competence and intense observation could not be the only foundation stones for the practice of art. So the art schools were cleaned up, until not an ounce of modernist experimentation remained. Hitler's revenge was to rebound for decades not just on any art that could be called realistic, but also on any art that appealed to the majority, to all those who came to the Degenerate Art show in their millions to laugh and mock. Any art that even hinted at a positive social agenda became politically suspect, even if it celebrated quiet domestic pleasures. People forgot that it was precisely this subject matter that had inspired the most radical art of the previous century, Impressionism. From the 1940s access to the high road of modern art was strictly restricted to splashy abstracts expressing a grimly isolationist view of human nature — just the artistic dish Hitler so despised.

This eclipse would have been partial, if the reaction against the artistic theories of the Nazis had not been taken up and augmented by the cultural politics of the Cold War. During the Second World War America was cut off from Europe, and it became, increasingly, a haven for Europeans escaping persecution, many of them intellectuals and artists determined to promote everything that Hitler condemned. They turned New York into a hotbed of modernist dissent. New York was also filling up with another class of people escaping from the war: the rich *culturati* of America, who had spent their time and money wandering around Europe collecting European art, had all been obliged to come home too. The enterprising Samuel Kootz spotted his chance. He had been interested in art as a student but had subsequently made a career in public relations. He was perhaps the first of a new breed of art entrepreneurs to emerge from

such a background, among whom Charles Saatchi is currently the most well-known.

In 1941 Kootz wrote a letter to the New York *Times*, which the editorial in the paper referred to as a 'bombshell'. Kootz declared that the future of painting lay in America and that they could no longer expect any help from abroad. 'We are on our own', he wrote. And yet looking around at the art exhibitions all he could see were 'old timers resting on their laurels, as if rigor mortis had set in'. Where, he asked, were all 'the bright white hopes'? He continued: 'Now is the time to experiment. You've complained for years about the Frenchmen stealing the American market — well things are on the up and up. Galleries need fresh talent, new ideas. Money can be heard crinkling throughout the land. And all you have to do, boys and girls, is get a new approach, do some delving for a change — God knows you've had time to rest'. The letter brought him instant celebrity status, an offer to mount an exhibition and an invitation to join the Board of Advisers of the Museum of Modern Art. He also opened his own Samuel Kootz Gallery.

The issue, Kootz knew, was not just to make New York the art capital of the world while Paris was occupied by the Nazis, as it had been since 14 June 1940. More importantly, the challenge was to maintain its supremacy after the war was over. This could only be achieved, Kootz realised, if the big spenders in America started to spend big money on American art. This, he knew, would not be easy to accomplish. While the well-off were spending money on American Art, the mega-rich still looked to Paris to find masterpieces of modern art. The latter did not believe that America could produce art of this quality, and took a European view of their own provincial school. The remark of the French critic, François Fosca — 'I would give all the contemporary paintings in the US for a few metres of American films' — summed up the general view. American artists at home, and dealers such as Kootz, keenly felt the lack of the presence of the great painted canvas in their domestic cultural crown. In fact, such a masterpiece had just been painted — Edward Hopper's *Nighthawks* — but for reasons we shall see later, this great painting would not do at all.

In 1943, Kootz thought he had found the artist who could deliver the goods: Byron Browne. Browne's art at the time was described as 'individual', 'athletic', 'aggressive', 'advanced', and gave evidence of 'constant growth' —

all attributes that many hoped would be shared by the American economy. This gives no idea of what Browne's paintings were actually like. In fact they now look like painfully sad imitations of Picasso. *The Four Horsemen of the Apocalypse*, as depicted in his triptych, could hardly look less alarming with their clippity-clop shoes, electric-whisk heads and B-movie Martian hairdos. It is easy to make fun of Browne at this distance in time when the difference between Picasso's innovations and the efforts of his followers has become so clear, but it is less easy to forgive Kootz. He was perhaps one of the first art dealers to apply the methods of marketing to his trade, adopting the by then well-known 'saturation technique' from radio advertising, making sure his artists' names were repeated, no matter for what reason, week after week in the media. By 1951, Mr Kootz realised that he had made a mistake and he suddenly sold all his Brownes in a deliberately demeaning sale in Gimbel's Department Store, treating them as ruthlessly as one would a portfolio of shares. This led in turn to panic selling by other collectors. Byron Browne was the first artist I know of to be 'dumped', a practice that was to become common in the increasingly cynical world of art. Browne never recovered, but who cared? By then Jackson Pollock had come along.

Pollock's art was not purely a product of the commercial pressure to produce home-grown, modern American art; it also sprang from fear. If America was to take a lead in the art world, as many like Kootz and his backers wanted it to, it had to produce art that was new. Someone had to act fast, and Pollock did exactly that. His action painting, as it came later to be called, was in part a response to the fear of American artists that they would miss the chance to produce original modern art. Pollock's art is also a manifestation of another more widely and deeply felt fear. Many at the time, not just in government but in business and among the public at large, thought that the world was building up to another war, and a much more dangerous one than before the explosion of the first nuclear bomb. There was a widespread perception in America of a devastated and divided Europe, ready at any moment to fall into the hands of communist forces marching west from Russia.

In the 1930s the American government, as part of its New Deal public expenditure programme, had supported traditional realist art with a socialist

21

agenda, much like that promoted in Russia and Nazi Germany. Publicly funded art before the war had been similar the world over. In the 1940s, as the Cold War addressed culture, the American government switched tack to promote abstract art both at home and abroad as a symbol of America's new role as the world's leading advocate of democratic freedom, and to condemn realist art as a manifestation of the oppressiveness of communism. Clement Greenberg, the rising critic of the new generation, quickly realised the financial implications of this. The new art would not be funded by the state — not, at least on anything like the scale of subsidy it had enjoyed before the war — nor could art be supported by a host of modest popular sales. What was needed to sustain the radical art of a new generation was an educated, or, at least, an indulgent rich elite. This coincided with Kootz's ambition to establish a 'blue-chip' market for contemporary art in America. When Clement Greenberg's friend, the wealthy heiress Peggy Guggenheim opened her new commercial gallery in New York in 1942, called Art of this Century, she gave Jackson Pollock his first one-man show and (unheard at that time, but a procedure that was to become commonplace later) an annual allowance to enable him to go on painting undisturbed. This realised Greenberg's dream of an avant-garde 'attached to an umbilical cord of gold'.

In 1942, Pollock was still painting — with brushes. His canvases were semi-abstract, with vaguely suggestive imagery designed to conjure up feelings from somewhere deep in the subconscious. Pollock had undergone Jungian analysis, and owned a copy of Kandinsky's *Concerning the Spiritual in Art*, which expressed the view that the 'basic rhythms of the universe' related to 'inner states of the mind' and that these could be revealed through art. Pollock's early attempts to do just this look very dated today — cryptic scripts, self-consciously meaningless, scrawled across rectangular spaces, the whole vigorously painted though essentially contrived. In 1943, he began tentatively to drip. *Untitled (Composition with Pouring I)* is abstract with pretty, predicable swirls, twirls and back-somersaults of dark grey brushstrokes, their interstices filled in with lemon yellow, brick-red or grey, with a very occasional patch of pale blue-green. The whole confection barely needs more than a second's attention before its earnest wish to be

interesting is revealed for what it is. Pollock appears to have felt the same, for, in a desperate attempt to enliven the whole artifice, he poured on black dribbles and splashes of paint, as if a demented spider, bathed in ink, had suddenly decided to dance across the painting. It certainly has the desired effect of making the picture come alive, but only because the dribbling stops before it totally obliterates what is underneath. Pollock's famous drip technique began as an act of destruction as well as creation. He once advised an artist friend to do the same: 'Go ahead, make a mess. You might find yourself by destroying yourself, and by working your way out of it.' It took him four years before he began pouring paint straight from the can — no need for brushes anymore! This was the great 'breakthrough', and the start of the eclipse in the language of painting.

Admirers of Pollock, then and now, always emphasise the degree of craft in his art; he did not just throw the paint on the canvas, they claim, but dripped and poured with the controlled elegance of a ballet dancer. There is some truth in this, but a drip tends to look like a drip however it is made. In fact, Pollock knew the limitation of this method and used all sorts of other techniques to create the effects he wanted to achieve in his paintings, as conservators looking closely at his work have recently discovered. He sometimes squeezed paint straight from the tube, and dragged it about with a hard edge of some sort. He rubbed whole areas of his pictures with semi-transparent glazes to make them glow with colour. Radiographs have revealed that he sometimes began his pictures by sketching the outline of a figure. He even occasionally used brushes to get the effects he desired. Had he not employed all these other techniques, it is doubtful whether his best pictures would be as delicately moody and atmospheric as they undoubtedly are. Not that he was cheating using these other means of expression; it was just that he was denying himself the opportunity of development in these directions, so identified had his whole artistic persona become with the drip. The English painter, Bridget Riley was one of many who thought that Pollock's art, while it might be exciting and liberating on the one hand, was at the same time 'a dead end', leaving 'nothing to be explored'. Perhaps Pollock realised this himself: when he had pushed his language as far as it could go, he started to drink again, heavily, and then

fatally. No artist could pick up where Pollock left off; none did, nor did it occur to anyone to try.

While Pollock was being promoted as the greatest artist in America, another painter much more deserving of such an accolade was being totally marginalised. In 1949, one of Edward Hopper's clients returned a painting he had just bought from him because his wife thought it was 'too communist'. The picture's title, *Conference at Night* (1949), made it sound clandestine, though all it showed was three office workers chatting at the end of the day. It captures beautifully a lingering moment between the worlds of work and home. Hopper was no communist, nor was he particularly interested in politics. He was an observer of modern city life, which he had been painting and drawing since the turn of the century. In the 1940s, he was at the height of his powers. While Pollock was soon to be heralded as *the* key artist of the second half of the 20th century — as influential, it is often still claimed, as Picasso was in the first — Hopper found his career blighted and his art ignored by the art establishment. It was not, according to Greenberg, writing in 1946, even *painting* in 'the full sense'. Greenberg explained what he meant: Hopper's 'means are second-hand, shabby and impersonal…his painting is essentially photography… and literary'. But both Hopper and Pollock used paint: how could one have produced paintings while the other did not?

Hopper painted his famous picture, capturing a moment of silence in a nearly empty New York diner at night, a few months before Pollock first began to experiment with drips. *Nighthawks* (1942) was the product of the slow gestation of an idea that had been lurking at the back of Hopper's mind for many years; it was not an instant snap. He made seventeen preparatory studies for the picture, the idea for which had been triggered by a diner he had seen lit up at night at an intersection on Greenwich Avenue. The final painting was in no way a photographic representation of that scene. Hopper made the restaurant much larger and simpler than the original, and the composition changed considerably as the painting developed. Hopper at first painted the couple facing each other, in a moment of intimacy. Then he turned them round so that they both stare ahead, lost in separate reveries. The waiter behind the counter was originally bent over, staring down. Then Hopper redrew his head, looking up

and staring ahead, ignoring his customers, as though thinking distractedly while his hands went on, mechanically, washing dishes in the sink.

All these subtle adjustments were not calculations on Hopper's part, but the instinctive development of his personal visual language. Hopper was an intuitive artist. The pose of the man sitting by himself with his back to the window echoes a drawing he made of a policeman attending a suicide in Paris in 1906. It is possible that something of this feeling of a recent, or imminent tragedy — a rare emotion in Hopper's work, which usually explores harmless moments of unguarded consciousness — has been transferred to the painting, sensed even by those who know nothing of the earlier drawing. Perhaps it was this which moved his wife to refer to the figures in the painting as 'night hawks', not as the more homely 'night owls'. Hopper himself was almost certainly unaware of all this as he was painting. He commented later: 'I did not see it as particularly lonely…Unconsciously, probably, I was painting the loneliness of a large city.' He was probably more interested in the fact that he had just seen van Gogh's *The Night Café* (1888), which was on display in New York that very January, and which he admitted influenced the picture, though in a very indirect way. *Nighthawks* merits examination in detail, and much more could be said about this haunting painting, if only to demonstrate that it was not just a photographic rendering of something Hopper happened to have seen, but an imagine gestated over a long period of time, which only took its final form when Hopper began painting on the canvas.

By comparison with the subtlety of Hopper's brushwork and composition, Pollock's art and so much of Abstract Expressionism which followed it, was not the *extension* of the language of painting which it claimed to be, but a development of only a narrow aspect of it. What Pollock did was new, but this advance was based on destruction, not construction. This was not a battle between abstraction and representation in art, though that is how it was always painted. It was, in fact, a ruthless diminution in the language of art as a whole. Up until the 1950s politics had not restricted the language of art in western democracies. Artists were free to paint abstracts or representational pictures, and nobody could tell from that whether they were left-wing or right-wing. There was a very honourable tradition of left-wing abstraction, beginning with Russian revolutionary

painter Kasimir Malevich who tried to evolve a new language of art for everyone, which would be abstract and classless. He saw his *Black Square* (1915) — a large black square painted in the middle of a square white canvas — as the beginning, not the end, of a new art for everyone. Sadly, this picture was used to mark his own end, for it was placed on his grave in 1935. Other artists of the Russian Revolution, however, wanted to adopt a realistic style showing happy peasants singing as they laboured. Abstract and figurative styles contended for a while — on official dishes and cups celebrating early revolutionary landmarks — but soon the realists earned political favour, and Malevich was put out to grass. In the free west, however, abstraction was still an option for an artist with left-wing sympathies right up until the 1950s. The socialist Artist International Association put on an exhibition of their members' work in London in 1952 called *The Mirror and The Square*, showing abstract and figurative art in equal measure. Nobody questioned the notion that artists were free to develop their artistic language as they chose. And anyone who has ever looked at a work of art with even an ounce of appreciation knows that it is just as impossible to create a representational image that has no formal, (or abstract) properties, as it is impossible to create an abstract image that has no associational (or representational) properties. Since all works of art are artifices, the division of art into two opposing camps, with representation on one side and abstraction on the other, is merely arbitrary. Common sense did not win and the main loser in the politicisation of art was art itself.

It was a common misconception that art had been heading down the road to abstraction for decades and that Pollock was only fulfilling the role laid down for him by history. In 1877 the English art critic, John Ruskin, had accused the American painter, James Abbott McNeill Whistler, of asking 'two hundred guineas for flinging a pot of paint in the public's face'. Whistler sued for libel. The court case, which Whistler won (though he was only awarded a farthing damages and had to pay costs which bankrupted him) has entered history as the *cause célèbre* of modern art. Ruskin was put on the shelf as a fuddy-duddy old Victorian, while Whistler was hailed as the herald of the 20ᵗʰ century. However as in the case of so many historical precedents used to justify modern art, the history of this incident has been totally falsified. It is always assumed that Ruskin, when

he criticised Whistler, was advocating realistic painting, with a Victorian prissiness of finish. Actually he was criticising Whistler for the decorativeness and lack of meaning in his work, not for its loose technique. Ruskin was a noted admirer of spontaneous brushwork: he had been inspired to become an art critic thirty years earlier when he read a critique of Turner's great *Snowstorm: Steam-Boat off a Harbour Mouth* (1842) which attacked it for being painted with 'soapsuds and whitewash'. The brushwork in this picture is much freer than anything in Whistler.

When Ruskin accused Whistler of 'flinging a pot of paint in the public's face', he was not criticising Whistler for his radical technique, but arguing that he had a cheek to ask so much money for a mere ornament. Whistler, famously, justified his price by saying that the painting was not the product of two days' labour, but of 'the knowledge of a lifetime'. Ruskin was criticising the picture in the context of an article he was writing about the need of society to pay fair wages to its workers (he had virtually given up art criticism at that stage in his life in order to argue for a more socially just management of the economy). The real argument behind this case has been totally obscured by the idea that modern art is perpetually progressing away from the past, and that it shocks supposed old fogeys, like Ruskin, as it does so. Had Pollock not actually *flung* a pot of paint, in his eagerness to be different, Ruskin's remark might not have been so repeatedly misinterpreted.

Whistler's famous comment that 'art should be independent of all the claptrap — should stand alone and appeal to the artistic sense of eyes' could have been uttered by Greenberg a century later, without a word changed. Yet, for Greenberg, the claptrap would have included anything that could in any way have been deemed representational, anything in fact that could be designated 'photographic'. Whistler loved the natural flatness of paint on canvas; he never wanted anyone to forget when seeing one of his works that they were looking at a painting — above all one by him. But when it came to brushwork emulating appearance, he was not nearly such a purist as Greenberg, though he had, one would have thought, more cause to be so. Photography was barely fifteen years old when Whistler started out on his career. Despite the threat of this new technology, the representational attributes of paint were, for Whistler, not in themselves

27

contrary to the nature of paint, not part of the 'claptrap' that had to be junked.

Another commonly held misconception is that painting skills declined when photography was invented: why should one learn the elaborate processes of making paint look like something it was not when the click of a shutter could do the job in a second? In fact the reverse was the case: the invention of photography acted as a stimulus to artists, not a deterrent, by encouraging them to develop their techniques in new directions, even, in some cases, to paint pictures that, in their rendition of vivid detail, outclassed photography itself. The paintings of Monet, Mondrian, Malevich and Matisse, not to mention those of Magritte, none of whose works could be describe as unskilful, prove the falsity of this popular myth. The idea that photography could be a bad influence on painting did not emerge until over a century after photography had been invented; and then it was used as a peg on which to hang an excuse. Critics and art theorists were looking around for a reason to attack art that looked like the official art of the Nazis or the Bolsheviks, but they did not want to blame politics for this, because that would have led them into a dispute they did not want to acknowledge. The new art was supposed to be above politics, so a non-political reason had to be found for its direction towards abstraction. Thus photography came to be blamed, as if it had just been invented, and any painting that looked even vaguely like a photograph was roundly condemned as reactionary. The fact that one method of painting (Hopper's), was not considered legitimate, while another's (Pollock's) was, resulted partly from the fact that modern art, in order to be modern, had to be progressive. It had to progress *away* from something — photography. But this was a nonsensical progression, since painting could not progress *away* from something it never was nor could ever be.

Painting and photography are two quite different languages because they are *made* quite differently. Painting is a totally created image, a hand-made product of the human mind. Photography is a mechanical process that need not go through a human mind at all. Though it can be guided and crafted, even with new digital technology, it cannot be totally created; if it is it ceases to be a photograph. Photography is essentially a form of casting transmissions of light on darkness. You do not *make* a photograph; you

take it. Even Henri Cartier-Bresson, the greatest documentary photographer of the 20th century, considered his work a form of pick-pocketing. It is significant that, for the past quarter of a century, Cartier-Bresson has given up photography and taken up drawing as a more contemplative, and ultimately more creative activity. Today the concept of developing art from what you can see around you has been outlawed by the confusion of painting with photography. Developing a photograph might be magical, but it is mechanical; developing an art has a totally different dimension of meaning. As Picasso said of the photographer Brassaï when he saw the latter's drawings: 'Why, you're mining a lead mine, when you could be mining a gold mine!'

There was worse in store for the language of painting as well-meaning intellectuals on the Left chose the casket made of lead, not the one made of gold. Dismissing American Abstract Expressionism as a product of capitalism, yet prevented from espousing Socialist Realism when Stalin's atrocities became known, where could left-wing artists turn? They could not propose a return to traditional academicism, with all its bourgeois values, so what was left? The English art critic John Berger eventually provided the answer. Originally trained as a painter, Berger had been a keen advocate of realist art right up until the USSR's invasion of Hungary in 1956. When the Cold War really began to cut deep, he left Britain to live in a peasant community in the glorious foothills of the French Alps, and write stories based around their lives. His television series *Ways of Seeing* (1972), cleverly published in book form as a montage of photographs and texts, was an isolated return to critical writing. It has had, and continues to exert, a tremendous influence on thinking about art, and about painting in particular. Greenberg had condemned all painting that looked like a photograph, while Berger trumped him by arguing that photography was better than painting.

Berger had been in the opposing corner to Greenberg in the art debate of the 1950s. When Greenberg championed art for art's sake, Berger argued with passionate clarity that the purpose of art was more important than its aesthetic quality. In *Success and Failure of Picasso* (1965) Berger criticised Picasso for failing to build on his achievement in *Guernica* (1937), and create images of great social consequence for our times. Picasso had

been reduced in his later years, Berger thought, to exploring personal feelings, particularly his own declining sexual powers. This was not so much Picasso's fault, but the fault of western society as a whole for failing to employ his talents for the greater public good. It never occurred to Berger, at that stage, to criticise Picasso for *painting*. Painting was still the unquestioned form which artists used to create images, whether for personal expression or the benefit of others. Berger's first novel, an attempt to paint a convincing portrait of a contemporary artist, was called *A Painter of Our Time* (1958), but twenty years later, painting had begun to lose its pre-eminent place in art's pantheon, and one of the most active iconoclasts undermining its very foundations was Berger himself.

The main thesis of *Ways of Seeing* is that the whole tradition of oil painting, from the development of the technique to its appearance inside gold frames, is a manifestation of the desire of man (particularly males) to take possession of things, including other people (particularly females). 'Oil painting', he argues, 'before it was anything else, was a celebration of private property. As an art-form it derived from the principle that *you are what you have*'. There is, of course, a substantial degree of truth in this, and the case is illustrated with animal paintings of well-bred livestock, portraits of well-bred people, still-lifes of table-tops groaning with rare delicacies, fine wine and wholesome bread. Classical scenes do not display an interest in Greek mythology, but the possession of educated taste; portraits of grand houses advertise property; landscapes show the extent of landowners' domains, at a time when, Berger reminds us, the punishment for poaching was deportation and stealing a potato could lead to a public whipping. Painting, in *Ways of Seeing*, is entirely on the side of the haves, and not of the have-nots. And when the latter are portrayed in low-life genre scenes, they are painted 'to prove – either positively or negatively – that virtue in this world was rewarded by social and financial success'. Adriaen Brouwer, who depicted the inhabitants of taverns with, Berger admits, 'a bitter and direct realism which precludes sentimental moralising' is the exception that proves the rule. Brouwer hardly sold a painting in his lifetime because his paintings did not fit into the category of what a painting ought to be. But by including works by Hogarth and Goya, Courbet and van Gogh, Berger could have made the case that oil painting is an artistic language capable of

revealing poverty and suffering as well as wealth and good-living. Instead he put the language of painting itself, rather than the people who used it, in the dock.

Ways of Seeing argues that painting is dead. Berger specifically refers to the tradition of oil painting, but the inescapable implication of his argument is that painting as a whole is dead. Berger does admit that there are other painting methods, though only one exception is mentioned, and that is a particularly idiosyncratic one, safely locked in the past. William Blake is waved through the barriers that Berger constructs around the medium of oils because he used tempera and watercolour, which enabled him to make his figures 'glow without a definable surface'. Berger ignores the fact that such effects are achievable in oils. This most adaptable of all painting media is as versatile in visual mimicry as the human voice, which can imitate more sounds than any other known animal. Nor does Berger make it clear that oil painting is only distinguishable from other types of painting by the linseed or walnut oil used to bind the pigments. One can bind pigments with egg yolk and egg white, lime, gum arabic and gum tragacanth, and, as Berger's contemporaries were increasingly doing, with acrylic. Berger does not position oil painting within the much wider context of the tradition of painting itself, nor at any time indicate the major role that painting, as a whole, has played in the history of mankind. By implication, he bundles all this away with the history of oil painting, which he argues effectively began about 1500, and ended, as he was perhaps the first to assert, in 1900 — a date for the death of painting that was soon to be recited like a mantra by the opponents of this art.

What does Berger suggest should fill painting's place? Photography: an art form that, by its very nature, is accessible and not exclusive, infinitely reproducible and so not collectable, cheaply available and whose possession could not therefore be used as a status symbol. Berger could not have predicted today's burgeoning market for extremely expensive, limited edition photographs sold as 'art works', the price of which would drop more dramatically if more images were printed to meet demand (which could easily be done). Photography, Berger assures us, keeping to the common understanding of this medium, is 'not, as is often assumed, a mechanical record'. He writes: 'The photographer's way of seeing is reflected in his

31

choice of subject. The painter's way of seeing is reconstituted by the marks he makes on canvas and paper'. That is the only difference; they both boil down to different ways of seeing. In this soup of ways of seeing, painting can do no right and photography no wrong, even when it is just as bad as a painting. One can begin to see why *Ways of Seeing* had (and continues to have) such a strong appeal, particularly to the young. It debunked a lot of art that needed debunking: religious paintings (by men and for men) that were little more than men-only magazines on billboard scale, and highbrow subjects that hid social snobbery. More positively, it opened the door to the serious analysis of the imagery that was all around; it made one feel that one was living in today's world and not in the past, with the additional bonus that one no longer had to visit museums. Though Berger tried to argue that it was still worth doing that, his illustration of a board in a child's bedroom covered with reproductions, cuttings, original drawings and postcards, above a caption which reads 'logically, these boards should replace museums' speaks more eloquently and is, in truth, more in keeping with the whole spirit of his argument, which primarily aims to knock the art of painting off its pedestal, not to point out how it can be uplifting.

Oil painting's sins are, in Berger's view, double-edged: it is not only the manifestation but also the means of wealth creation. The rich did not just commission paintings of what they possessed, those paintings themselves then became valuable possessions in their own right. Berger writes: 'The art of any period tends to serve the ideological interests of the ruling class. If we were simply saying that European art between 1500 and 1900 served the interests of the successive ruling classes, all of whom depended in different ways on the new power of capital, we should not be saying anything very new. What is being proposed is a little more precise; that a way of seeing the world, which was ultimately determined by new attitudes to property and exchange, found its visual expression in the oil painting, and could not have found it in any other visual art form. Oil painting did to appearances what capital did to social relations. It reduced everything to the equality of objects'. Thus, Berger goes on to claim, oil painting is incapable of expressing religious feelings: it is simply too materialistic. He illustrates his argument with a couple of paintings of Mary Magdalene in which her naked breasts distract the viewer from contemplating her

renunciation of her previous way of life. Women who are represented naked in other traditions of art — in India or Africa — are, according to Berger, never presented passively in this way, but are usually shown to be assertive and often as sexually active as men. Oil painting is nothing less than the tool of a materialistic and sexist Satan.

Ways of Seeing played the feminist card to great effect. In the early 1970s feminist art critics such as Linda Nochlin in her 1971 essay, *Why Have There Been No Great Women Artists?* and Germaine Greer, with *The Obstacle Race: The Fortunes of Women Painters and Their Work* (1979), charted the difficulty women had in breaking into this male-dominated profession, unless their fathers happened to be artists (like Artemisia Gentileschi and Judith Leyster) or they had the courage to wear trousers in order to be allowed into slaughterhouses (like Lady Butler). None, of course, could be allowed in the life class, unless they were models, when they were welcome, so long as they had nothing on. Lee Krasner, the painter who met Jackson Pollock in 1941 and married him in 1945, recalled how women were treated like cattle in the bars and clubs where the artists met. The painter, Hans Hoffmann was quite specific: 'Women cannot paint,' he said, adding, 'Only men have the wings for art'. Eventually Krasner showed with her husband in 1949, in an exhibition entitled 'Man and Wife' (an impossible nomenclature today). The associations of brushes with penises and paint with semen and in Pollock's work, in particular, with ejaculation, were too tempting to be ignored, especially in the heady Freudian atmosphere of New York in the 1940s.

In 1946 Marcel Duchamp created a little picture entitled *Paysage fautif* (variously translated as *Wayward* or *Faulty Landscape*), consisting of an amoebic, globular stain of semen, now encrusted and discoloured, spewed across a patch of thin gauze backed with black satin. It could be interpreted as a comment on Abstract Expressionism. Freud's analysis of the painter's motivation runs thus: 'Urged on by instinctual needs…he longs to attain honour, power, riches, fame, and the love of women; but he lacks the means of achieving these gratifications. So, like any other with an unsatisfied longing, he turns away from reality and transfers all his interests, and all his libido, on to the creation of his wishes in the life of fantasy'. Renoir's alleged remark: 'I paint with my prick', capped it all. By the year 2000 these

ideas had become so ingrained that Tate Modern could cite solemnly, on a label, that 'Matisse's works exemplify the idea of male dominance over a passive female'. But their place in the gallery is justified by the fact that though Matisse's 'treatment of the female form has its roots in 19th-century conventions', he 'used it as a site for the re-invention of artistic traditions'. To those in the establishment, then, sexism could be forgiven if it contributed to the advance of modernism.

Outside the establishment, the act of painting itself became the focus for feminist ridicule. In 1965, the Japanese artist Shigeko Kubota made her *Vagina Painting* at Perpetual Fluxus Festival in New York. Crouching over a canvas on the floor, she moved about painting a woman's Action Painting, with a brush dripping with red paint hanging from her panties. This was a feminist riposte to both Pollock and Yves Klein, who used naked women as 'human paintbrushes' in his Happenings of the late 1950s and early 1960s. In 1971 Judy Chicago produced her infamous *Red Flag*, a photolitho of herself from the waist down pulling out a bloody tampon — a response to Jasper Johns' paintings of the Stars and Stripes. The mere sight of a brush dripping with paint was enough to announce the presence of a man. As the new feminist histories made clear, women had been almost totally excluded from the mainstream art of painting, and restricted to marginal roles producing crafts that were 'decorative', 'precious', 'miniature', 'amateur', 'sentimental'. To make this point Judy Chicago's *The Dinner Party* (1974–79) celebrated the lives of women through history using crafts traditionally associated with women, from pottery to quilting, with the exception, of course, of the craft of painting.

One British woman artist, however, had no truck with this kind of feminism. As far as she was concerned, she was an artist first, and her sex was irrelevant. Bridget Riley was, like many, bowled over by Abstract Expressionism when she first saw it. She felt it was 'an explosion of vitality', and drew strength from the fact that what later came to be called 'the cutting edge' had not stopped with the outbreak of the war, but was still alive. As she said, artists like her now felt they 'had a present as well as a past'. The art she produced was aggressively modern (perhaps in part to make sure nobody labelled her as a woman). Her art was not just non-representational in that it lacked any internal illusionary depth; it came

out and hit you, almost literally, in the eye. The conjunction of colours was chosen for their optical effect and how they activated the rods and cones on the retina, so that, when you stood in front of her work, at the right distance, the painting was actually happening *inside* your eye. She made a great deal of this: her very best paintings such as the little black-and-white *Blaze 4* (1965), a flame in moonlight, or the long, sumptuous red, green, blue and white *Punjab* (1971), a shimmering, golden mirage in the heat of the desert, provide experiences of memorable radiance. When these effects are compared with the emotional resonance of colour in a Matisse, or in a great Persian carpet, this self-imposed restriction is revealed to be an aesthetic limitation. Riley seemed to need to create a rod for her own back.

Riley's small, early studies after Seurat suggest that she could have worked in a much freer, more painterly way. But when she got into her stride, any trace of a brush mark, any sign that her work was handmade was ruthlessly eradicated. Her lines were ruled; the paint looked as though it had been applied by a machine; masking tape was used to ensure that the edges were sharp. What had to be eliminated was any hint of human presence. That would have been almost a betrayal, like taking a step backwards. Illusionism in art depended for its effect on a human perspective — the perspective of the Renaissance. Modern artists could no longer see themselves as the centre and measure of the universe, only as minute particles in an endless continuum. Riley and Pollock share this sense of a centre-less, overall spread, of individuality obliterated in their work. But where does that lead? If a work of art is not centred on humanity, what is its form? Why stop at the edge of a canvas, when one could cover the whole wall? The next logical step — and it was only round the corner — was to deny the language of painting its separate identity altogether.

This clinical look had another appeal: there was a genuine enthusiasm, after the grim years of rationing, for all that was spick and span and modern. Many artists and students at the time felt that it was not merely a pleasure but a *duty* to use modern technological methods and materials when making art. Such was the demand for mechanical finishes in art in the 1960s and 1970s, that you could quite easily walk through many art schools in those days without seeing a paintbrush. Spray booths were as essential a piece of equipment in the painting studios as vacuum-form machinery

35

was in the sculpture departments. Nobody went into the etching room, with its resins and carbons, feathers and copper plates, and great, old, wooden hand-pulled wheels, but there was a queue to use the presses for screen-printing and lithography, with their shining tubs of bright, synthetic paint, squeegees and photosensitive screens, with push-button controls and racks to collect, automatically, each gleaming, immaculate new edition. The 1960s saw a blaze of synthetic colour on cars, on dresses, ties and underwear, in newspapers (with their new weekend colour supplements) and by the end of the decade on television screens as well. Even food now came in shining packets (not in brown-paper bags) designed so that they would attract desiring fingers whichever way they were stacked on the new supermarket shelves. Now everything was brightly packaged, even holidays. This bright, new era of the consumer product seemed in direct contrast to very act of painting: labouring alone in a studio, with a bunch of hog-hairs stuck on to a wooden stick in your hand, dripping with pigments ground from the minerals mixed with oils extracted from seeds, facing a wooden stretcher covered with a length of canvas made from linen or cotton fabric, working in daylight hours only (perhaps the last trade to do so), producing a unique image that few people would ever see and which cannot be exactly replicated, even today. It is hardly a wonder that painting, to many, soon seemed as obsolete as the wooden plough.

The trouble was that many of the new techniques were not tried and tested. Many modern synthetic pigments are rock solid — you could paint them on to the roof of your car in the burning sun and they would not lose their brightness — but other media were not so lasting. The abstract artist, Alan Green, told me how a client had once brought back a picture that he had drawn using felt-tip pens because the image had totally faded. All that was left was a blank sheet of paper and Green's signature, which he had written in pencil. Serious problems, not to mention ethical questions, begin to arise when modern artists started to use fugitive materials in their work. Many acrylics, PVA glues and plastics, used extensively by artist in the 1960s, are intrinsically unstable. They yellow, craze and crumble however carefully you look after them. Many works of modern art are literally disintegrating in museum stores; others have a limited life. What will happen to Dan Flavin's art, for example, when fluorescent tubes are no longer

available, as they will surely come to be in time, in the dimensions he uses? Sarah Lucas, the Britpack artist, insists on using real fruit in her assemblages, melons and cucumbers — at least they can be replaced regularly. But what about body fluids? Duchamp's *Paysage fautif* is now in the collection of the Museum of Modern Art, Toyama, Japan. I pity the conservation staff who have to try to preserve this caked and yellowed semen stain for posterity. Accidents will happen, as when a technician at the Saatchi Collection unwittingly unplugged the refrigeration unit that was an essential part of Marc Quinn's *Self* (1991) — a cast of the artist's head made from his own, frozen blood. This work of art simply melted away.

There are media, however, that can preserve their primal freshness over centuries. One example should suffice to illustrate this point, though it will come as a surprise to many artists today who do not appear to have heard of its invention: paint. If all those artists today who relish the sight of blood, dripping from tampons, or oozing out of wounds, or frozen to form heads, knew that blood, when rendered in paint, does not darken to a dullness then fade to nothing, but remains a glistening, liquid ruby for ever, as if it were just spilt, how much more horrific the sights of modern art would be. At least then we would be able to judge them for what the artist actually had to say, rather than have to guess the artist's intentions from the remnants of a has-been. A language is only any good if you can use it to communicate.

'Moving images' are, many would argue, the leading media of our times, and it is true that some of the most interesting sculpture of our age has been kinetic. It is as if sculptures during this eclipse had to leap about to attract attention, like the remarkable British sculptor Jim Whiting who creates visions of heaven and hell with flying shirts and trousers and snapping handbags. There has always been a relationship between sculpture and dance. But the skill required to make a still image move you is not the same as that required for a film. 'Video art' needs to be judged in relation to other achievements within its own language; it is special pleading to consider it as an art form on its own. To give just one example, the soundless, floating, plastic-bag sequence in Sam Mendes's film *American Beauty* is as evocative as any 'video piece' I have ever seen. No one would dare bring the achievements of the world's film directors to bear on the productions

of videos in art galleries, because, if they did, they would virtually wipe this abortive art form, with its pretentious pricing structure, off the slate. Of course, artists of any mettle will not be bound by rules; they will choose the elements they need to create the images they want, and clearly our technological age will produce art the like of which has never been seen before. That does not mean to say that anything goes, or that artists who venture to express themselves in media outside the general practice of visual art can insulate themselves against critical comparisons with other creative expressions in that medium.

I have referred throughout this chapter to visual art as being a language, not a craft. Art is not just a craft, though I am not, by saying this, denigrating craftsmanship. Many people criticise modern art for not being well made, but it is too simplistic to do this. A rapid sketch of a dancer can, for example be just as beautifully crafted in its way, if its aim is to give an impression of her movement, or a drawing detailing all the hair follicles in her skin, if its aim is to praise the appearance of her flesh. The quality of a technique can only be judged in relationship to the artist's purpose. If treated as an aim in itself, craft becomes a trap. It is better not to make a work of art at all if your labours only amount to a display of skill and the work itself has nothing to say. That is why art is more than a craft; it is a language. But referring to art as a language is also to misrepresent it in one crucial way. Art is not a language because you cannot use it to converse. It is a one-way communication. It can in its developmental stages, as we have seen with Hopper's *Nighthawks*, provide a means by which the artist can have a conversation with himself, as he works out his ideas. But, for the most part, a work of art is a completed statement, given from the artist to his or her public.

Many artists in recent times have come to feel uncomfortable with this one-way process. They want art to be more of a give and take between the artist and the viewer, capable of being used as a conversation and a vehicle for the exchange of ideas. Such artists came to see the very concept of a work of art as a form of dictatorship. These egalitarian sympathies were given a tremendous boost by new theories about the nature of language itself, which were emerging during the 1960s in France. Put crudely, these stated that language is nothing more than a construction out of a myriad

of influences; when you start to unpack these the very idea of anyone having their own 'individual voice' disappears. There is clearly a great deal of truth in this. The mistake was to apply this approach to art, which is not an accumulation of layers of meaning over time belonging to no one, but an artificial construction at a particular moment belonging to an individual, or, in some cases, a closely knit group. Art can only exist if someone has made it. Art is also always the product of a personal perspective, however subtle and ambiguous that might be. Artists are perfectly free to raise wide public issues in their art if they want to (though many, equally legitimately, do not). Art may question things but art can never be just a question. It cannot be because art is not a language in which questions can be discussed. 'To be, or not to be: that is the question' is not a question but a poetic statement. Art always expresses a point of view, even when at its most elusive.

It is often maintained by the pundits of modern art that a urinal, or an ashtray or an unmade bed can legitimately mean what anyone looking at it wants it to mean. But the public are right to ask where is the art in that? They know perfectly well that they have no choice but to think their own thoughts when looking at such 'found objects' because it is impossible to know from just looking at them what the artist intended you to think or feel about them, because they have not been changed by the artist in any way. They are still a urinal, an ashtray or an unmade bed, whether they are in an art gallery or not. The audience, far from being engaged in a debate, is in fact left totally at sea. They would not be if Tracey Emin had written the question 'can an unmade bed be a work of art?' on the walls of the Tate. The audience would then be able to discuss the question, if they found it interesting, fully engaged, as equal partners, talking the same language. When Emin exhibited the bed, she was not talking the same language as her audience. Her visual statement remained opaque while the public talked and generally wondered what it meant. This is art pretending to be a language it is not. You can debate whether something is art or not until the cows come home (or get sliced up) but art is not a language of debate. It is at once less than a language and more than a craft. Art is a language of expression and it manifests itself through craft.

Paper construction exercises in the preliminary course run by Josef Albers at the Bauhaus, 1928–29. In 1928 Albers wrote: 'We are going to experiment…we are going to focus on beauty as skilfulness. How we apply this depends on the material we are working with'.

CHAPTER TWO

The Eclipse of Learning

Languages have to be learnt, and the same is true of the language of art. The meaning of a work of art can often hit you with immediate and surprising force, yet to appreciate all its subtlety and richness, you need to understand its grammar and vocabulary. You certainly have to learn the language of art if you want to make a work of art, and that can be only be done by practising it, by experimenting and making mistakes and, by this process, eventually, finding your own voice. The style of even the greatest artists, like Rembrandt or van Gogh, took time to form. Some artists take to a particular form of expression very early in their lives, and find they love doing it and can express themselves through it, and do not want to do anything else. This instinctive choice of language seems to be a trait in human nature. It happens in all cultures around the world, even those in which visual expression is extremely restricted. An Islamic calligrapher once told me that he had started to draw letters when he was six; he just found that he could do it and was fascinated by it. Fortunately his family was sympathetic and he was able to study. When I met him he was a master with many pupils. He was lucky; he had found a form of expression that could sustain himself personally, both in his spiritual and material life, which was fortunate for virtually no other forms of artistic expression are allowed under many current interpretations of Islam.

The crucial thing artists have to do when starting out on their careers is to select an artistic language that excites them with its potential for development. The options for doing so have narrowed in the increasingly ideologically and commercially restricted atmosphere of modern art. The situation has been getting worse, not better, since the onset of the Cold War. Günter Grass has described how his first wish was to be an artist; he painted and drew incessantly, and dreamt of becoming a stone carver. At art school in Berlin in 1953 he found not only that the city was partitioned, though the Wall had not yet gone up, but the art school was too. On one side were the supporters of American abstraction led by Will Grohmann;

on the other, the advocates of figuration led by the head of the art school, Karl Hofer. Grass was of the Hofer party. The exchanges between the two were vicious and personal. Then Hofer died suddenly, perhaps in part due to the strain. Grass found himself increasingly isolated, and began to write, developing his imagery verbally in ways he was unable to do visually. The 20th century could, in the process, have lost a great sculptor, although it gained a great writer.

Günter Grass was prevented from learning his chosen language of art. The key thing that all artists have to learn, once they have chosen their form of expression, is how to make images that express their feelings and ideas. This is true whether they are carving a block of marble or painting a picture, assembling a construction or manipulating an image on a computer screen. Ultimately the success of any work of art depends on the artist's ability to convey meaning through making, and that ability springs from the development of the artist's eye-to-hand co-ordination. One learns art by making it not by thinking about it. But it is exactly making skills that are demeaned in the world of art today, so much so that they are virtually not being acquired at all.

From time immemorial, artists used to learn in the studios of their masters. Until recently some still did. Lucian Freud, surprisingly enough, trained in the studio of the idiosyncratic, at times radiant painter, Cedric Morris, who also bred wonderful irises for his garden in Suffolk. His faux-naif portraits are noted for their large, haunted eyes. What Freud added to these watery spheres was a glistening introspection (he was not Sigmund's grandson for nothing). Freud was following an age-old practice. Until the Industrial Revolution, art training was carried out through the apprenticeship system. Any child of twelve or so (usually, though not exclusively, male) wanting to become an artist, perhaps because his father was one, or because he was attracted to it for some reason, would, if he had the talent and the contacts, apprentice himself to a practising artist for seven or eight years, and end up either being employed in his master's workshop or setting up business by himself. It was impossible to short-circuit this training because many of the basic skills, such as grinding pigments and building up a ground, required years of practice to perfect. Even more importantly, many of the materials used in painting were, in themselves, very expensive: no working

lad could afford to experiment with gold and azurite and malachite on the kitchen table at home. He had to train where these materials were readily available — in a successful artist's studio.

The academies of art that began to spring up across Europe in the 18th century were collective apprenticeship schools, run by masters from the academy. These schools effectively created a closed shop for the art trade, while at the same time giving it added status. Artists wanted to be ranked not with craftsmen but alongside poets. The new academic training was supposed to give painters intellectual standing. But already class divisions were beginning to rear their ugly heads: was art a career for those who were good with their hands (the working classes) or for those who were good with their heads (the ruling, now managing, classes)? Even the most superficial survey of the contemporary art scene would suggest that the heads have won and the hands lost out entirely. There is no room now for that occasionally resurfacing dream, that flourished so wonderfully during the Renaissance, that society can benefit if it finds a place for those who want to be good with their heads and hands together.

It is often thought that the Industrial Revolution put paid to this concept forever; in fact it gave it a fillip. It is true that the advent of mechanised means of production changed the nature of apprenticeship training forever. There was no need to spend years learning how to mix colours if you could squeeze the paint ready to use straight from a tube (paint tubes did not emerge until the mid-19th century, which, incidentally, is why very few painters worked outdoors before the Impressionists). The Industrial Revolution brought with it the need for new types of artists who could make a fender round your fire, or a gas street light, or an iron bridge look attractive and, therefore, marketable. The public art schools that sprung up for the first time in every city and large town in Britain during the 19th century, and later throughout the western world, started off as colleges for designers, not fine artists. This was partly because the Royal Academy in Britain wanted to keep its virtual monopoly on the training of 'fine' artists, but also because the urgent requirement was to supply the applied artists and designers that British manufacturers would need to make their goods saleable in the new markets opening up around the world. These colleges were effectively the invention of one man, the remarkable arts' administrator,

Sir Henry Cole. Cole's South Kensington Museum (which was, short-sightedly, split after his death into the Victoria and Albert Museum and the Science Museum) was the linchpin of his nation-wide educational programme to prepare Britain for the burgeoning Industrial Age. Every student had to learn to draw, but painting and sculpture were not taught there for their own sakes.

Many were worried by this training, and saw a sad diminution of the human spirit in the proliferation of machine-made ornament. The critic, John Ruskin, as usual, put it most elegantly: 'All the stamped metals, and artificial stones, and imitation woods and bronzes… will not make us wiser or happier…They will only make us shallower in our understanding, colder in our hearts and feebler in our wits'. He wanted workmen not to copy things but to make and invent things for themselves. This was the spirit behind the company set up by William Morris, who put into practice many of Ruskin's ideas. It has been caricatured as being 'arty-crafty' and against mass production, but that is an oversimplification, as the success of many of its lines, such as its wallpaper designs, proved. Nikolaus Pevsner, the great architectural historian, was adamant in his appreciation of the importance of Morris: 'Not one of the founders and principals of the schools of decorative or industrial art down to almost the end of the [nineteenth] century had an idea of the organic inter-relationship between material, working process, purpose and aesthetic form which William Morris rediscovered. It is therefore due to him and his indefatigable creative energy alone that a revival of handicraft and then industrial art took place in Europe'. The great innovative art college in Germany, the Bauhaus, essentially took these ideas a step further, into the 20th century, using 20th-century materials and manufacturing methods.

The Bauhaus was in essence an attempt to update the apprentice system to produce designers for the modern world. Students at the school spent most of their time apprenticed to a master in a particular trade, usually related to architecture, such as furniture making or lighting design (though painting was allowed) in order to pass their city trade exams. The Bauhaus itself provided introductory training in the principles of basic design, founded on the abstract languages of colour and tone, form and line, and showed how these could be applied to modern materials, particularly metal

and glass. The student finished his or her career working on a real project run by the Bauhaus. It was a long training and intensely practical, never purely theoretical. Most importantly and most radically, the fine-art element was not treated separately but integrated into the training. Walter Gropius, the guiding spirit behind the school, wanted to break down what he saw as the false division between art and utility, and in the process discover creative possibilities in mechanised processes which would in turn lead to a new architecture. A radical design for a light bulb, he thought, could enlighten the world. Creative work such as this, it was believed, could not be done by designers and engineers alone, but needed the input of artists. Kandinsky and Klee were among several painters who were only too happy to teach at this school, which did so much to transform modern thinking about architecture and design, from when it was opened in 1919 until it was closed by the Nazis in 1933.

After the Second World War, art education in Europe became increasingly divided, between applied art and design on one hand and fine art on the other. The old class divisions reasserted themselves; the development of hand skills remained with the former while the latter became increasingly cerebral. Now the former have begun to go in that direction too, as more and more products are designed on computer screens, (especially in colleges where workshop practice is becoming more expensive to provide), while the manufacturing processes themselves are often being undertaken miles away, in a different country, where labour is cheap and pollution controls are lax, with the overall result that, as Ruskin predicted, we are all becoming 'shallower in our understanding, colder in our hearts and feebler in our wits'. But the plight of modern art is our concern, not the state of modern design. One would have thought that fine art, being essentially a skill in which passionate, individual attention has to be paid to all aspects of the created image, would have retained the craft basis in its training much longer than design. But, if anything, the reverse has been the case.

This was partly because the language of art was itself so decimated after the Second World War. Josef Albers had taught at the Bauhaus for ten years before moving to America where he became, perhaps, the single most influential figure in art education, teaching first at Black Mountain College, North Carolina and subsequently at Yale University, and elsewhere in the

country whenever he could. He brought with him in his suitcase only the elementary building blocks of the Bauhaus, not its whole, crazy catholic vision of creativity. His teaching programme, which had been lively and practical in the early years at the Bauhaus became increasingly purist and theoretical, like his pictures which always employed the same format — three superimposed squares of different colours. His work was the epitome of post-war abstraction, and the teaching of art suffered as the language of art was decimated. There was no point in learning to draw a figure if you would never have to paint one. So a generation of artists emerged who had never learnt to draw. As Robert Hughes remarked, 'the cackhandedness of Julian Schnabel', who daubed outlines of human forms across batteries of broken plates and whose efforts that were widely acclaimed as heralding the resurgence of figurative art in the 1980s, was 'not feigned but real.' Before long artists did not dare put pencil to paper for fear of exposing themselves and their incompetence. But then many argued that drawing, so long regarded as the foundation of all visual creativity, was anti-art because it was too personal. As early as 1950, Albers listed what art was not: 'No smock, no skylight, no studio, no palette, no easel, no brushes, no medium, no canvas, no variation in texture or *matière*, no personal handwriting, no stylisation, no tricks, no twinkling of the eyes'. He did not, however, add 'no teachers'. Teaching was a haven for artists who could not earn a living elsewhere, and this was to bring problems to art schools in Britain.

Sir Henry Cole's vision of an art school had, by the end of the Second World War, been reduced, in many cases, to a couple of rooms containing a life class, two sewing machines and a kiln — they were totally inadequate to meet the training needs of modern production. The man brought in to update the system was Sir William Coldstream, a painter of elegant landscapes and surprisingly sexy nudes, in the manner of a very muted mid-period Cézanne, with every detail carefully measured, from hilltop to treetop, nipple to kneecap. He once said, 'measuring is like fly fishing', and possessed a similarly well-ordered mind and a whip-like tongue. As an artist himself, he wanted to see fine-art training greatly improved, but he had also to cater for the growing needs of design. 'Coldstream', as the new system came to be called, streamlined art education across England. The plethora of little art schools was condensed down to a quarter, creating

powerful independent institutions in most urban centres, capable of providing their students with a whole range of experiences and introducing them to the latest new techniques, such as vacuum forming and photographic silkscreen printing. There were four main areas of study: fine art, textiles, 3-D design and, by far the most popular, graphics. For the first time, fine art was seriously taught within the public education system, but it was almost too late for painting and sculpture. These ancient craft techniques had been less exposed while colleges of art occupied old, Victorian buildings. But as soon as they moved into larger, modern premises, students dropped their chisels and started making casts with epoxy resins, and discarded their brushes and oil paints for spray guns and acrylics.

The Coldstream system encouraged this modern approach. It was based on Bauhaus principles: the belief that both the students of design and those of fine art needed to be kept in touch with contemporary developments in their fields, or else the training would ossify and rapidly go out of date, as had happened in the previous system. The solution was, in effect, to revive the idea of apprenticeship. They proposed that the art-school system in England should be run as much as possible by part-time teachers who were also practising artists and designers in their own right. On the design side this worked quite well: successful cutlers, couturiers and car designers could be persuaded to visit colleges from time to time. On the fine art side, the situation was very different: there were not enough artists who were commercially successful and at the same time acceptable to the art colleges to supply the system. In the world of the fine arts at that time, success in the market place was usually interpreted by the avant-garde as an indication of artistic failure — selling meant selling out. There was a widespread feeling, especially among students, against the creation of art that could be owned at all. Unintentionally, the Coldstream system gave a boost to this non-commercial approach to art, because it effectively channelled a substantial state subsidy into the pockets of radical artists who, having landed a part-time lecturing job, focussed their creative energies, when they were teaching as well as when they were not, on generating political dissent. Stimulating as all this was, it was not good news for training in the traditional craft skills of art, particularly painting, which after Berger's *Ways of Seeing* was dismissed as a gilt-edged product of the ruling classes.

Apprenticeship survived for all those who wanted to create a new fashion item or dream of organising a political insurrection, but not for those who wanted to learn to draw, paint or sculpt.

As it happened, the Coldstream system did not last more than a decade or so. The new art colleges were soon dragged, kicking and screaming, into polytechnics which, in turn, became universities. Within four decades art education in England had been transformed out of all recognition. In the 1950s, a boy of thirteen could begin his training by going to his local art school, and start by learning to draw, slowly working his way up through the grades, learning perspective and anatomy, drawing from the antique and from life, until he was proficient enough to draw a design from his own imagination, while learning, in conjunction, the basic skills of painting or sculpture, pottery or carpentry or whatever craft his college could afford to offer. The same boy intent on a career in art in the 1990s would not have started any specialist training in art until he was at least 18, when he had won a place at a university that offered courses in art and design. Even then he probably would not specialise, but would be more likely to combine fine arts, with, say, media studies or film, or graphics with computer programming, in order to acquire 'transferable skills'. He would work mainly at home, when he was not doing the part-time job that enable him to pay for his course, because studio spaces could not now be provided for every student. Obviously this new system favoured the development of a theoretical rather than a practical approach to art, and conceptual art fitted the bill perfectly because the job of the artist in that tradition was to think not to make. You do not need a studio to think in — you can do that just as well in the pub.

The path that led to theoretical training of art had been laid two centuries before when Sir Joshua Reynolds, the founding president of the Royal Academy, argued in his *Discourses* that painting was an intellectual pursuit, not a craft. How glad he would have been to learn that art schools today were now part of universities and students of fine art were awarded degrees. In 1973, Harold Rosenberg, the American critic who coined the term 'Action Painting', observed that, while only one out of the ten leading artists of Pollock's had an academic qualification, all the prominent painters of the next had university degrees. 'Can there be any doubt,'

he argued, 'that training in the university has contributed to the cool, impersonal wave in the art of the sixties? In the classroom — in contrast to the studio, which has tended to be dominated by metaphor — it is normal to formulate consciously what one is doing and explain it to others. Creation is taken to be synonymous with productive processes, and is broken down into sets of problems and solutions'. He went on to blame Josef Albers's work specifically for this. Albers concluded his list of what art was not by adding: 'I want my art to be as neutral as possible'. There is a death here — the death of art. It is also the death of learning, and the cessation of its only manifestation: growth.

There is a remarkable parallel between the ambition of the German-born American, Josef Albers in 1950, with that of former East German artist, Gerhard Richter. He was born in Dresden in 1932, but managed to escape to West Berlin in 1961, just before the Wall was erected. Brought up under the communist system, he later professed a horror of any ideology, whether of the left or right, which left him, in effect, with another ideology: to have none. Among notes to himself, jotted down between 1964 and 1965, published later in a collection called *The Daily Practice of Painting*, he wrote: 'I want to leave everything as it is. I therefore neither plan nor invent: I add nothing and omit nothing. I steer clear of definitions. I do not know what I want'. One day Richter can paint a huge blown-up, realistic imitation of a photograph of, say, his family, or a flickering candle, or the Baader-Meinhof gang, and, on the next, paint a huge, blown-up Abstract Expressionist picture, streaked with multi-coloured pigment. He reproduced one of these abstracts in *An Artist's Book* (1978), which contains 128 details of the painting in black-and-white, but no image of the whole. Painting does not come more eclipsed, and clipped, than that. No one would know, just by looking at them, that Richter's photo-realist paintings and his abstracts were by the same artist. His aim, his apologists tell us, was to 'undermine the age-old belief that an artist has to have a single voice'. In the catalogue for the huge retrospective of Richter's work that was held in New York in 2002, Robert Storr compares Richter most favourably with Velázquez and Vermeer. How can he when Richter, by his own admission and declared intention, has not developed any artistic identity — something those two great masters most certainly and most gloriously achieved?

What has been lost in art today is any commitment to the idea of personal development. This is surprising since so much emphasis is still placed on this lower down in the education system. The discovery that young children's attempts to express themselves through paint were similar the world over and largely free of cultural stereotypes, encouraged educationalists at the beginning of the 20th century to believe that they had stumbled on something universal in human nature which could provide the building blocks to create civilised individuals. Herbert Read wrote poetically about this, particularly in his immensely influential book *Education Through Art* (1943). The *through* was important, because he saw art as a means by which we could all become fuller, more contented human beings and create a more just and culturally richer society. 'Every man is a special kind of artist,' he wrote, 'and in his originating activity, his work or play, he is doing more than express himself: he is manifesting the form which our common life should take, in its unfolding … The way to rational harmony, to physical poise, to social integration, is the same way — the way of aesthetic education.' For, he continued, 'until man, in his physical and sensuous modes of being, has been accustomed to the laws of beauty, he is not capable of perceiving what is good and true – he is not capable of spiritual liberty'. By this means Read believed a 'natural society' could be built up from the foundations of elementary art education.

Read's writing struck a deep, hopeful chord. The stylistic breakthroughs of modern artists such as Picasso, Matisse, Kandinsky and Klee had already opened people's eyes to the natural beauty and vigour of what any child of five could do. Growing interest, too, in the art produced by society's outsiders — the artist Jean Dubuffet had friends combing the world for powerful examples to add to his collection of *Art Brut*, now in Lausanne — added weight to the growing awareness that art could play a key role in emotional and psychological development. It was a short step from there to the belief that art could be personally therapeutic, an attribute that is still disputed if only because its effects are difficult to isolate from other beneficial influences. Great works of art have long been thought to have a benign, cathartic effect on their audiences. In the 20th century it came to be believed that the process of making art itself could benefit the maker. The place of art in modern education seemed assured.

And so it proved, at least at kindergarten level. An infant school today without children's art on its walls would seem almost shockingly inhuman, as would the home of a family with young children in which none of their pictures were on display, if only in the kitchen and their bedrooms. The concept that everyone is an artist, deep down, but that something goes wrong at puberty, is now embedded in our self-perception. Most people do not mind not being artists in adult life, yet many go on harbouring a belief that they have a creative core hidden somewhere deep down in their nature. The fundamental question still has to be asked, however: are artists born or made? Seeing the waves of joy splashed down in paint as every new generation begins to walk and talk, one would unhesitatingly assert that artists are born. But seeing pubescent pupils churn out the same detailed pencil drawings, year after year, of shells and skulls and sliced red peppers, shiny reflections on Coca-Cola cans (whole in the 1960s, crushed ever after), and the endless stream of tatty pairs of unlaced trainers, doubts set in. Artists are not born or made; they are born and unmade. Paintings might line the walls of pre-school classes, but as one goes up the age range, art disappears from the educational system.

Looked at one way, it is hardly surprising that art suffers an eclipse during puberty, when so many strategies are adopted by individuals to disguise the turmoil going on inside. Art might continue, but it usually turns into something intensely self-conscious and mannered. Many educators have tried to address the problem of how to sustain the child's spontaneity, intensity and sensitivity into adult life, but I know of none who have come up with an answer. In traditional Aboriginal cultures, puberty is the time when the young adults are given their cultural roles in adult society, the signs and symbols, sounds and stories that they will need to keep alive all their life and which will in turn help them to live. There is no such handover of symbols in our society, though the need is there. The unselfconscious, exuberant paintings of children are usually followed by self-conscious, introspective drawings of teenagers. Both are often still encouraged at school. But there are fewer and fewer places for would-be artists to develop image-making skills after that, and very few that offer practical training hand-in-hand with mental stimulus. Most of the great artists of the past started their apprenticeships when they were twelve, or

even earlier. Now a craft studio which still provides on-the-job training, the Cardozo Kindersley letter cutting workshop in Cambridge attracts apprentices in their late twenties, many of whom have already gained degrees and left careers that they found dissatisfying.

What is required is a revival, in contemporary terms, of the apprenticeship system in the arts. Lida Cardozo Kindersley has described in her book *Apprentice* (2003) how she was taught to cut letters in stone by her master, and later husband, David Kindersley. He himself learnt his craft in the workshop of the great innovator in letter design, Eric Gill. Lida Cardozo Kindersley teaches her apprentices today techniques that are at least a century old and which cannot be learnt in any other way. As she says, 'by doing it, you get the feel for it, and it's the feel for it you can't get out of books'. The challenge for any visual artist is to relate the process of making with the process of seeing; it takes time and effort to make the hand and the eye begin to work together in this way. As David Kindersley put it: 'The first principle to be mastered is a complete change of attitude towards time. Complete mastery of a few elementary techniques must take place in an atmosphere of timelessness. Slowness alone will permit the head to guide the hand at first...perhaps the most difficult thing to teach is the necessity to watch what is going on in one's hands...hurry, and the lesson will not be learned. Speed comes with time'. This is as true for painting as it is for stone cutting, and all the craft skills which are central to the survival of the visual arts.

In the end, however, no educational system in itself will produce artists; they have to form themselves. In France, during the early 19th century, painting was not taught in schools at all. Art, and then only in the form of drawing, was not introduced into the syllabus until 1853, and then in a rather idiosyncratic way as a means of developing a taste for the ideal, and to understand human emotions. Children began to learn to draw an ear or a nose, and when they had perfected that could go on to another part of physiognomy, eventually ending up being able to draw a whole face. Few got that far and fewer even tried, because there were not many teachers who had the ability or inclination to teach the skill. The syllabus was re-jigged in 1878, with accuracy of representation being the sole aim. With the use of a sharp, hard pencil and a ruler, pupils were taught first to copy

from prints, then to draw models of cubes and cones, then antique vases or plaster casts of classical architectural ornaments, and finally, if they had persisted that long, and few did, the figure. And who was responsible for these lessons? The maths teacher — in the age of Monet and van Gogh!

None of this had any discernible impact on the French art world, however. Anyone with the inclination to paint or sculpt could study in the studio of a master, or one of the increasingly open academies. They would stand a good chance of earning a decent living supplying the State or the Church, institutions or businesses, and, increasingly, private collectors who wanted pictures to hang on their walls and sculptures to line their halls. That market is substantially depleted today, though it could be revived if people were once again encouraged to have an original work of art on their wall rather than a reproduction, or, worse, nothing. If it is not, painting will become a dead branch of the heritage tree, with its techniques only being taught in conservation studios, and, in the most rudimentary way, in playgroups, with its skills only being practised in adult life as a form of therapy. The self-taught Glaswegian artist, Andy Hay, once told me how he was painting a view of tower blocks in one of the city's outer housing schemes, when a lad came up to see what he was doing. He asked him, with some admiration, 'Where did you learn that? Art school?' Andy shook his head. 'Prison?' Perhaps painting will soon only be taught to adults as part of rehabilitation programmes, behind bars.

A Conception of a Conceptual Gallery

1 *Arrangement* 10, 1965. Eight heating grills.
2 *A Wallflower*, 1975. Two heating grills.
3 *Six Heating Grills*, 1985. Household paint on six canvases.
4 *Down with the Fucking Working Classes*, 1995. Suspended heating grill with wire.

Note: The four heating grills on the left are not an exhibit.

CHAPTER THREE

The Eclipse of Content

In 1991 Robert Hughes added another chapter to his hugely popular book *The Shock of the New* (1980) to bring it up-to-date. It was to be the last chapter because, he assured his readers: 'The age of the New, like that of Pericles, has entered history'. He did not venture to say what he thought would come afterwards, except that he was sure of one thing: the next phase of art would not be new or shocking. He was instantly proved wrong. No sooner had he put his pen down, when Damien Hirst burst on the scene, producing some of the most shocking new art of all, and undermining the validity of comparing the triumphs of modernism with the culture that built the Parthenon. Hughes never defined what he really meant by 'new' and the word has been so debased it can be applied to virtually anything. It no longer means those rarest of rarities, something genuinely new to the whole of human experience, such as Darwin's idea of evolution, which was so disturbing that it made him feel physically sick for most of his life; or the terrifying sight of the agonisingly slow-moving, welded-together limbs of those victims of the first nuclear bomb who escaped being killed outright.

The trivialisation of the word 'new' seems to have begun in 1947, when the term 'New Look' was coined for Christian Dior's post-war fashions. 'New' soon became a catch-all word, almost as meaningless as 'nice'; it only really makes sense as a determiner in the negative, indicating that something is not like what has gone before, but not specifying how it is different, like the 'new' in New Labour. The same is true of 'new' art. The Patrons of New Art at the Tate are a body of sponsors (including many art dealers) committed to raising funds for acquisitions (and, incidentally, also responsible for funding the Turner Prize). If they had called themselves the Patrons of Experimental Art, we would have had a better idea of what they were looking for. Equally, if the organisers of the exhibition *A New Spirit in Painting* held at the Royal Academy in 1981 had called it *A Disturbing Spirit*, or even just *The Spirit of the Age* we would have had some

idea as to what exactly had governed their selection, beyond the fact that none of it was old in spirit, whatever that might mean.

It is now widely accepted that the major role of the artist is to express the 'new spirit' of the age. In reality is this not a diminution of the artist's role? Surely the task of the artist is more ambitious: to find lasting meaning in the transient. This does not involve cutting oneself off from fashion, or from the evanescent experiences of everyday life; it means seeing significance through them. As William Blake put it: 'He who bends to himself a joy/ Doth the winged life destroy;/ But he who kisses the joy as it flies/ Lives in eternity's sunrise'. Artists cannot escape their times, try as they might. Henry Moore worked hard to create timeless sculptures, by draping his figures in simple robes and shrinking his heads to nodules. As time wears on, his groups look increasingly dated, as if they were playing classical charades in the 1940s. The faces on his sculptures, though their features are diminutive and generalised, almost look as though they are wearing period make-up. Those artists whose work dates the least are often those whose work is the most intensely contemporary, but that does not necessarily mean they are just trying to capture what is 'new' about their times. No one would think of calling van Gogh's art dated, though it is intensely of its times.

This obsession with what is new has narrowed both the artist's and the wider public's ambition for what art can be about. The 'newness' of, say, a Barnett Newman — an American abstract artist who painted huge canvases divided into one or two blocks of glowing reds, cool blues and rich browns, often separated by strips of black — prevents us from asking ourselves whether his work gives us anything more than we would gain from looking at, say, the work of Piet Mondrian, a Dutch artist who painted abstracts using pure reds, yellows and blues in a black grid format, though on a much smaller scale than Newman. Mondrian worked during an earlier period, though not that much earlier: the two artists were painting for a while at the same time and in the same city. In many ways the painting Mondrian completed just before his death in 1944, *Broadway Boogie-Woogie* (1942–43), which expressed his response to New York through an unusually jazzy arrangement of colours, sowed the seed for so much of what happened afterwards in American abstract art. Yet there has never been, as far as I know, a detailed critique comparing the artistic value of Mondrian's work with

the efforts of the artists who followed him. It is as if these two generations of art existed in separate compartments; they could not be compared because they were not about the same thing, nor even belonged to the same family. This marks a sea change in the history of art. Before the Second World War, art was seen as a continuum; the experiments of the avant-garde were adventures, however irritant, within the total spectrum of art, not activities designed to separate their perpetrators from it.

The term *avant-garde* derives from the tactics of war. In traditional military strategy, the avant-garde remained a small, highly skilled, quick-thinking, and, one might add, devious and unprincipled section of an army. It was sent ahead to assess the lie of the land, spy on the enemy's position and, if necessary, eliminate the advance guard of its opponents. Many took the opportunity to desert, or switch sides. Art's progress can be likened to an army of artists marching on a broad front together, against art's eternal opposition — our continuing capacity to be insensitive, ignorant, narrow-mindedly materialistic, defeatist and joyless. Its avant-garde is at the extreme right-hand end of its line (or to the left, depending on your politics) darting out to irritate the opposition as the massed ranks of art slowly move forward. Then someone, sometime during the last century, suddenly shouted to this vast army 'Turn right! Quick march!' and everyone turned to follow the avant-garde.

The man doing the shouting is generally thought to have been Guillaume Apollinaire. His writings inspired the young Robert Hughes, and he is widely regarded as the first great advocate of the avant-garde. Apollinaire was big-jowled and striking, with sparkling, penetrating eyes and a mind to match. He thrived in the heart of the Parisian art world during the intensely creative years at the beginning of the 20th century. He wrote the first key reviews of Matisse and Picasso, introducing the latter to Braque; he organised the Cubist room at the Salon in 1911, championed Delaunay and Orphism, wrote one of the Futurist manifestos and coined the term Surrealism. It seemed as if no 'ism' was an 'ism' without Apollinaire. Like a firefly, you never knew where he would light up next, until he died suddenly of influenza in 1918, aged only 38. Picasso wept when he heard the news. Though Apollinaire had a driving ambition to push art forward on all fronts, he did not regard this as a movement away from the art of the past,

but a continuum of its greatest achievements. One of his friends was André Breton, the Surrealist poet, who later argued against the drift towards pure abstraction in America in the 1940s, which he believed 'generally serves the extremely impure ends of reaction'. Apollinaire wrote to Breton: 'I am convinced that art itself does not change and that what makes one believe in changes is the series of efforts that men make to maintain art at the height at which it could not help existing'.

Apollinaire's instinct, when he saw something really new, was to emphasise its continuity with the past. So his first review of Matisse's work, written in 1907, begins: 'Here is a timid essay on an artist who, I believe, combines in himself France's most appealing qualities: the power of her simplicity and the sweetness of her clarity.' Could one ever imagine one of the apologists for today's art beginning a review with timidity? Apollinaire goes on to emphasise Matisse's debt to Giotto, Piero della Francesca and Duccio. He saw his job as to enlighten, not to take sides in a battle, still less attack. He describes his visit to the exhibition (Matisse was there) thus: 'When I came towards you, Matisse, the crowd were looking at you and laughing, but you were smiling back. People saw a monster, where, in fact, there stood a miracle'.

We need to consider, for a moment, that laughter and that smile. Laughter is a complex reaction; it usually contains a volatile mixture of confidence laced with unease. You do not laugh when you are shocked, though you might laugh when you are surprised. Matisse's art in 1907, to his contemporaries, was certainly surprising, almost unimaginably so. His art still has the capacity to surprise us today, with its casual disregard of all finishes that were irrelevant to its artistic purpose. This makes it look technically inept to those with less experience of the expressive potential of paint whereas, in fact, it is technically exact. Laughter is not necessarily an unhealthy reaction from those coming across such art for the first time; it could register nothing more than their confidence being challenged. Apollinaire put it beautifully, as ever: 'Surprise laughs wildly in the purity of the light'.

How much one would welcome hearing such laughter in the grim, hallowed halls of Tate Modern, and in so many of the galleries of modern art around the world, instead of all the politically correct, hushed silence one

finds there. An outburst of incredulous laughter in such places would be greeted with shock and instant condemnation. It would be as if the philistines had been let in: all those who queued to guffaw at the exhibits in the Nazis' Degenerate Art Exhibition in 1937. But the laughter in the Matisse exhibition in 1907 was very different from that in Munich thirty years later; at the latter exhibition, the artists were not smiling. Matisse was smiling because he was confident of his direction. The artists represented in the Degenerate Art exhibition were stony-faced, not because the visitors were laughing (though they would have preferred them not to) but because their ambition to be artists was being denied them. It was that ambition for art which was so heady in Paris at the start of the last century. Laughter, then, was part of a healthy, critical reaction. The modern art world since the Nazis' has lived in fear of laughter — or rather in fear of being on the wrong side of the laughter, in fear, they think, of missing the next van Gogh.

It is difficult to say precisely when the myth of van Gogh as the first tragic hero of modern art began to take hold. Gradually, over the years, the misconception has gained ground that van Gogh was totally misunderstood in his lifetime, particularly by the general public, and lived despised, rejected and in poverty, until he ended it all. The truth was significantly different: in fact it seems quite possible that van Gogh shot himself because he got his first good review. It is true that he sold only one picture during his lifetime, at a half-decent price of 400 francs. It is certainly not true to say that his art was not appreciated when he began to exhibit, which he only did in 1888, eight years after he had taken up art in preference to religion, at the age of 28. The first response to van Gogh's work was not one of shock and horror, but rather the reverse: that there was nothing much to shout about. One anonymous critic wrote that he painted 'vigorously', but 'without very great care for the value or exactness of tones'; another questioned his choice of subject, wondering whether a pile of books could 'afford the pretext for a painting'.

The following year, however, the praise started to flow. It began as a trickle: one critic wrote that 'Mr Van Gogh is an entertaining colourist', though with 'extravagances'; then another wrote, 'Here are canvasses by Vincent, tremendous in their ardour, intensity and sunshine'. The writer of that comment, the young critic Albert Aurier, then sought out the artist,

and having secured some biographical details, wrote a full article on him, praising his 'dazzling colour', 'powerful draughtsmanship' and 'sometimes (but not always) great style'. These 'strange, intensive and feverish works', he wrote, spring from 'an excessive nature in which everything, beings and things, shadows and lights, forms and colours, rears up, stands up with a raging will to howl out its own essential and very own song'. Van Gogh was most upset by this and wrote to his brother on 29 April 1890: 'Please ask Mr Aurier not to write any more articles on my painting, insist this to him, to begin with he is mistaken about me, then that I am really too overwhelmed by grief to be able to face publicity. Making pictures takes my mind off it, but if I hear them spoken of, it hurts me more than he can know'. Three months later Vincent went into an orchard and shot himself in the head.

Van Gogh's reputation blossomed with surprising speed after his death. In 1892 he was first referred to as a genius, the first full exhibition specifically devoted his work (a very rare honour in those days) took place in 1901; the first book reproducing his work appeared in 1907, the first biography in 1916. By 1920 fake van Goghs began to be sold on the market, and in 1924, the National Gallery in London acquired his *Sunflowers* (1888) to hang alongside the greatest paintings in the world. The other critics agreed with Albert Aurier's assessment: phrases such as 'a born painter', 'rapturous temperament', 'shimmering', 'wonderful qualities of vision', 'magnificently gifted', 'the blinding intensity of his canvases' poured from their pens.

There was only one contemporary dissenting voice, and significantly it did not come until 1893, when van Gogh's art was already all the rage. Then Charles Merki wrote in *Le Figaro*: 'He has found not only admirers, but also imitators. His so abundant colour, which in many places is several centimetres high, has aroused infatuations. And yet, how can one not believe it is a fraud? This man has fought with his canvases. He has hurled clay pellets at them. He has taken mortar from a pot, and flung it before him while tasting the scoundrel's joy in striking blows. Whole trowelfuls of yellow, red, brown, green, orange, and blue, have burst into flower like the fireworks of a basket of eggs thrown from the fifth storey. He has brought to this the pump and with, his eyes closed, has drawn a few lines on it with a finger soaked in gasoline. Apparently, this represents something, pure chance, no doubt'. You would be forgiven for thinking he was describing a Julian

Schnabel. Significantly and exceptionally the editor prefaced this article with a disclaimer: 'Mr Charles Merki is expressing purely personal opinions here'. The paper also carried some extracts from van Gogh's letters, which were already becoming appreciated for their 'incomparable wisdom, moderation and lucidity'. Charles Merki's review has all the hallmarks of professional jealousy, of someone in the know wanting to cut another down to size. This is not the writing of an outsider who knows nothing of art, but of one whose tastes are set in the art that he likes.

Art which is genuinely original is more likely to upset the art world and those with a vested interest in maintaining the status quo, than the public at large. In van Gogh's case this is particularly true, because there is considerable evidence to suggest that he painted with ordinary people in mind, rather than the critic in *Le Figaro*. As Gauguin wrote shortly after his friend's death, van Gogh's 'need for warmth' led him to be 'suffused with charity' and a 'love of the meek'. He did not paint pictures of the poor and the old, the postman and the peasant, for rich collectors and aesthetes, but for his subjects. His bold outlines and strong colours were derived from the language of popular, cheap chromolithographs, invigorated by the woodcuts from the newly-opened Japan, which had first arrived in Europe as wrapping paper for luxury goods. These pictures were not sophisticated effusions for bourgeois drawing rooms. Van Gogh was delighted to show his paintings in Pere Tanguy's paint shop, and certainly identified closely with the working classes, simply because his heart was all-embracing. As soon as his paintings became accessible, millions of ordinary people, without any art training, took him to their hearts as well.

Where, then, did the myth arise that van Gogh's works were scorned by the ignorant masses? It most likely emerged from the art world itself. It is true that many of his contemporaries found van Gogh's art difficult to take. Emile Bernard and Paul Gauguin both admired it, though they had reservations; Renoir thought it too full of 'exoticisms' while Cézanne dismissed it as simply 'mad'. It would be difficult to imagine two painters at more opposite ends of the artistic spectrum than van Gogh and Cézanne: the former exposing every vein of feeling, the latter condensing all emotion into an intellectual vision. Professional jealousies are some of the fiercest; that is why most of the public, hearing about a row in the arts,

look for a moment with wonder at what all the fuss is about and pass on. It was the realist painter Gustave Courbet who reputedly compared Manet's masterpiece *Olympia* (1863) to a playing card, or as he put it, 'the Queen of Spades in her bath'. He liked his women round. Manet, for his part, thought Courbet's paintings were like 'billiard balls'.

Manet's magnificent life-size nude portrait of the beautiful young Victorine Meurent, *Olympia*, outraged the art world and the gallery-going public for two, quite distinct reasons. First, it was painted with an unfamiliar, realistic vividness: the flesh on her naked body is lighter than that on her face and neck, and glows with a delicious luminosity. Second, Victorine was just the sort of Parisienne that many respectable Parisians wanted to keep hidden from their wives. Manet's adventurous development of art, which was beginning to emphasise light over form, was quite distinct from his challenge to public mores. He was, in the latter role, only following in the footsteps of the Old Masters. Titian had painted his *Venus of Urbino* (c. 1538) showing a no less luscious nude in a similar pose, and Velázquez had painted the same subject, the *Rokeby Venus* (c. 1648) but from behind. In 1752, Boucher had got away with painting a prostitute lolling naked against silk sheets in a much more provocative pose than ever used by Manet and nobody turned a hair. But then Boucher was painting for the aristocracy (there is evidence to suggest he was in the line of procurement for Louis XV, who favoured young virgins because of his fear of venereal disease) and the lower classes had not yet asserted their moral authority.

Manet's *Olympia* was painted after the Revolution when a righteous and prudish middle class held sway. It was not the dramatic change in style between his art and Boucher's that outraged the public — it was the public itself who had changed. These two separate facts — that Manet was an adventurous painter and that a few of his pictures, though only a few, shocked the art-buying public — have been elided into one by those wishing to glorify the origins of modern art. In breaking the bounds of contemporary morality, Courbet was much more of a radical than Manet: his paintings of prostitutes ignited a storm of protest, and his private work was more explosive still: no artist before or since has painted lesbian love-making with such explicit sympathy, nor made female genitalia the focal point of a picture. But Courbet, the realist, did not fit into the canon of

modernism, so his radicalism has been conveniently forgotten. Manet's art, however, was seen to herald the increasing tendency towards simplification and abstraction which, Greenberg later argued, achieved its apotheosis in the 'flatness' of American Abstract Expressionism. The public's outrage at Manet's art was, forever after, upheld as proof that the radical progress of art offends public taste; and the delusion grew, nurtured by those in the art world only, that art had the power to change society by changing itself.

Art, at best, can only show us what our experiences of life are really like (with the requisite ingredient of praise). Art can never provide us with a programme of what we should do about what we see. That is the difference between art and politics, but this does not mean that art cannot be political. What artists choose to show us can affect how we see the world. The exercise of this artistic right was the cause of the great split between Zola and Cézanne. They had been boyhood friends, swimming together in the River Aix (Cézanne's late *Bathers* are, in part, a memory of that happy time; his early drawings for them depict boys not girls). Zola wanted art to raise awareness of social injustice, and there is no more moving account of the hardship and suffering of a miner's life than in his *Germinal* (1885). Zola dreamed as a boy that he would become France's greatest novelist and Cézanne would become France's greatest painter. But when Cézanne took to painting apples, Zola gave up on him. They never spoke again. People less personally involved were not so bothered and could see the respective merits of writing about strikes and painting still lifes. The promoters of modernism, however, favoured Cézanne over Zola — after all, he had paved the way for Cubism. They conveniently forget, then, that one of the fiercest opponents of this latest development in art was Matisse himself. It was he who, as Apollinaire recounted, coined the name 'Cubism', in derision. Matisse was taking sides with Manet against Courbet, and held up a playing card up beside Picasso's little cubes.

It is generally accepted that van Gogh opened the door to Fauvism and Matisse, but it is not generally acknowledged that he also paved the way for Edward Hopper. The former influence is allowed in our increasingly narrow interpretation of the history of modern art, but the latter is not, because it is generally accepted that Hopper took a step backwards to realism, not a step forwards to abstraction. Hopper has no place in Robert Hughes's

The Shock of the New except for a passing mention as having been an influence on the 1980s' realist Eric Fischl, who specialised in painting (intentionally badly, it appears) sordid scenes heavy with sexual innuendo in sunlit Long Island rooms. They smell, as Hughes memorably puts it, of 'unwashed dog, barbecue lighter fluid, and sperm', and thereby earn their place in the canon of the new because of their capacity to *épater les bourgeois*. Edward Hopper's great painting *Nighthawks*, though it is just as 'new' as any Fischl and its paint handling is just as modern, does not merit a mention because it shocked no one. Hopper was certainly a painter of his time, and profoundly so. His art can be interpreted as Existentialist, just as much as Pollock's has been. The fact that Hopper's work was sidelined at the time, and not even reinstated by a critic as open-minded as Robert Hughes, shows just how deeply inculcated the assumption is that art, to be modern, has to be distinctly different and offensive. Art's content in the second half of the 20th century came to be shorn of anything that was recognisable and enjoyable. No modern artist worthy of the name could aspire again, as van Gogh had done, to produce art that would be all-embracing, popular, loving and profound, and art today is the lesser for it.

Tom Wolfe, that arch-opponent of all vanities, spoke for many when he described, in his wonderfully bracing attack on modern art *The Painted Word* (1975), how for 'all these years I, like so many others, had stood in front of a thousand, two thousand, God-knows-how-many thousand Pollocks, de Koonings, Newmans, Nolands, Rothkos, Rauschenbergs, Judds, Johnses, Olitskis, Louis, Stills, Franz Klines, Frankenthalers, Kellys, and Frank Stellas, now squinting, now popping the eye sockets open, now drawing back, now moving closer — waiting, waiting, forever waiting for...*it*...for *it* to come into focus, namely, the visual reward (for so much effort) which must be there, which everyone (*tout le monde*) knew to be there — waiting for something to radiate directly from the paintings on these invariably pure white walls, in this room, in this moment, into my own optic chiasma'. As an avid gallery-goer, as well as deeply sensitive and intelligent observer, Wolfe had seen most of the trends over that period; he knew the artists and their dealers, the curators and the critics, and grew increasingly to distrust what they were about. He began to think they were about nothing, and said so. Modern art, Tom Wolfe declared, had disappeared

'up the fundamental aperture', and he, like so many of his generation and many more since, turned his attention to more rewarding aspects of life.

The Painted Word is still one of the best and most vivid condensed histories of American post-war art, despite its cutting sword-play. Wolfe was immersed in the scene, and famous figures such as Robert Rauschenberg and Jasper Johns peer through his text as eager, young, fresh-faced artists, just as they were before they achieved celebrity status. It was then that they produced their best work. Johns's brushwork is delicious, even though the flags and numbers he endlessly painted counted for nothing in themselves; they were just vehicles for *belle peinture*. Rauschenberg's handling of paint was even stronger; he used it to express the tumultuous excitement of city life. They were both painting more instinctively than theoretically in the late 1950s and early 1960s, but they were at the end of the line, not the beginning. Wolfe thought he was just witnessing a barren period when the content of art was becoming hamstrung by theory. It did not occur to him that the very language of art itself was under threat. He wrote: 'Theory did not come into its own, triumphant, transcendent, more important than painting and sculpture themselves, until after the Second World War'. Wolfe thought painting and sculpture would survive as they had always done, and that he would ride back again over the hill when artists came to their senses. He would have been surprised to learn that 20 years later readers would ask: 'More important than *what*?'

The thesis of *The Painted Word* is that theory has been put before creation in art, and killed it stone dead at birth. But this was only part of the story. Had Wolfe concentrated his attention on the mythology of progress in art, and the political and commercial aspirations of the United States at that time, he would have seen more clearly how the half-baked theories he so roundly castigated could have exerted such a stranglehold. Had he done so, he might have seen that Harold Rosenberg's theory of Action Painting was not just, as he argued, the failed rival of Greenberg's theory of flatness (though much more popular with the public) but that *both* were signposts to painting's oblivion. Rosenberg maintained: 'What was to go on the canvas was not a picture but an event'. So, if the action was the thing, why bother with paints and brushes? As Yves Klein soon realised, nudes (always girls, they make better patterns) covered in wet paint and rolling

about on a canvas could create a pretty picture. But then why bother with the paint? – or the canvas? Nudes would do well enough just being nudes. Painting was disappearing in the Rosenberg, as well as in the Greenberg camp, but Wolfe was too absorbed in following the scent of flatness to notice this. The shortcoming was that Wolfe had no theory (but then how could he?) to put in the place of the ones he had so brilliantly slain. He fondly hoped for better times, but things got worse and art got even thinner.

Julian Schnabel's paintings of the late 1970s and early 1980s were supposed to be a reaction to this thinness. His creations can best be described as the aftermath of a drunken painters' banquet. Upended table-tops are swimming with congealed paint in which are stuck heaps of broken plates, over which the host has managed to scrawl, before he passed out, some incoherent message — a sign of mythic potency, such as a cross, or just simply his mark, indicating that he has been there. They were artists' *Last Suppers* and they sold like hot cakes. The plates might have kept falling off, but at least no one could say that they were flat. Schnabel attacked Greenberg as 'one of the most destructive, inane, positivistic, and stifling forces against the growth of art in this country'. If he had not, modern art (and Schnabel as its foremost flower) could not have become the constructive, profound, negative, liberating force it aspired to be — or so his dealers claimed, and many public art galleries around the world believed, from the Whitechapel Art Gallery and the Tate Gallery in London to the Centre Pompidou in Paris, from the Houston Museum of Fine Arts to the San Francisco Museum of Modern Art. They all showed Schnabel, and Charles Saatchi collected his work by the barrow-load to exhibit in the gallery he was converting from a paint store in North London. The only thing that convinced me that they had some merit was when I happened to see a student rally in the early 1980s. It struck me that the clothes they were wearing in the then current 'grunge' style looked like a Schnabel on the move. Think what a modern-day Bruegel could have made of such a scene! The overall effect of Schnabel's work was that it was of its time: not even Schnabel could escape that attribute, though individually his canvases left no lasting impression.

It does not really matter whether art is thin or fat, cool or hot, minimal or baroque; what matters is what it is about. The notorious 'Tate Bricks', *Equivalent VIII*, were made in 1966 by the American artist, Carl Andre.

He selected some smooth white bricks from a building-trade supplier and placed them in different configurations on the floor, stacked as rectangular podia of different dimensions, two bricks high. The Tate acquired one set of these. It was not a *pile* of bricks, as conceived in the popular imagination; that would have been much too expressive. *Equivalent VIII* has a certain classical simplicity, a sense of proportion even; it could be the base for a miniature classical temple, and would make a fine pedestal for a reclining bronze, but it is difficult to look at it for long for its own sake.

Its content was equally elusive when it was first exhibited. Peter Schjeldahl, the American art critic who later wrote the introduction to the first major catalogue of the Saatchi Collection, described his first sighting of the bricks with disingenuous frankness: 'As a naive newcomer to New York and also to art in the middle 1960s, I was a pushover for the shocks and delights, the puzzlements and sensations of that liveliest of eras. Among the cognoscenti, with whom I yearned and despaired of being numbered, Andy Warhol and Frank Stella were already established masters, Jasper Johns and Robert Rauschenberg were old masters, and Jackson Pollock and Willem de Kooning occupied the farthest, mistiest reaches of the classical past...In March 1966, when I entered the Tibor de Nagy Gallery and saw some bricks lying on the floor: eight neat, low lying arrangements of them, construction in progress, I thought, and I turned to leave. Then another thought halted me: what if it is art? Scarcely daring to hope for anything so wonderful (I may have held my breath), I asked a person in the gallery [is it art?] and was assured, that, yes, this was a show of sculpture by Carl Andre. I was ecstatic. I perused the bricks with a feeling of triumph ... here was an art which existed in relation to me and which, in a sense, I created ... With them at my feet as I walked around the gallery, accumulating views, I felt my awkward self-consciousness, physical and psychological, being valorised, being made the focus and even the point of the experience...here, at last, was the purely and cleanly existing heart of the matter'.

Nobody bought the bricks when they were first exhibited, so Andre returned them to the supplier. He had to order a new set when the Tate wanted them. *Equivalent VIII* can be seen today in Tate Modern, placed on the grey composite concrete floor, surrounded by a little, protective rail (an angry visitor once threw ink at it). Other Andre floor pieces, metal tiles

67

of different colours, arranged in square or strip formations, lie nearby, unprotected. You can walk on them, though few visitors do, unless by accident, because it is difficult to see what one would gain by doing so, and in any case many were unsure whether they are works of art or not. In one corner of the gallery there is a set of three metal grids, each divided into 214 equidistant slits, set into the floor and not protected by a little rail. It is not obvious, at first, that these are any less visually interesting than the other exhibits in the gallery, until one realises that the reason they have no accompanying label is that they are the gratings for the gallery's air-conditioning system. If you think such objects are not worthy of your attention, you need only go round the corner into the next gallery and see Julian Opie's *H* (1987), which is an exact replica of a real heating grid, propped up on the floor, with 22 slots in its aluminium frame, a gift from the Saatchi Collection in 1992, and surrounded by a little rail. Thank goodness for the little rails in Tate Modern! They help you distinguish what is art from what is not.

The fountainhead of found objects was, of course, Marcel Duchamp, as Schjeldahl made clear when he wrote about his first sighting of the bricks: 'The one early modernist with the dispensation of awe was Marcel Duchamp because no way had been found to outflank his scepticism. In those days scepticism was rapture'. Yet Andre had trumped even Duchamp, so Schjeldahl believed, because 'Duchamp's readymades gestured. The brick works *were*'. To celebrate the Millennium in 2000, the Tate acquired a replica of Duchamp's famous urinal, called *Fountain*. The original disappeared soon after it was exhibited in 1917; having fulfilled its role in art, it was, presumably, put back to its proper use. Duchamp, seeking immortality in 1951, commissioned a replica of his urinal, which is now in the Philadelphia Museum of Art. Then, in 1964, he authorised eight more, presumably because he was in need of more fame, and cash. The Tate has just bought one of these eight, each personally 'authenticated' by the artist (as what, I am not sure), a bizarre procedure for what was originally a readymade. The Tate have a policy of not revealing the prices they pay for the art they buy for fifty years, even though they are spending public money. While we do not yet know what the Tate paid for their *Fountain*, we

can guess because in the very year they bought theirs (1999) one of this edition sold at auction for £993,789.

How can one lay the ghost of Duchamp? It is like trying to lance a chimera: there was never anything there, and the few paintings he produced in his early career show it. Even *Nude Descending a Staircase* (there were two versions, one in 1911 and another in 1912) — one of the few images of his that almost begins to become visually interesting — is ultimately little more than a clever confection on an imposing scale. Duchamp wanted to be a painter, but he lacked that elusive gift which is the only thing a painter can build upon: that ability to develop a dialogue with his or her thoughts and feelings through the language of brushes and paint. Had he had such a gift, he would have gone on painting. But in 1912 he realised this activity was getting him nowhere and he began working in a totally different way, making, at infrequent intervals, art objects out of things he had found, such as a bottle rack, a comb or a typewriter cover. No one so far, despite the reams written about him, has been able to make sense of these works visually, nor understand the thinking behind them. They seem to be wilfully obscure gestures, as if designed to make Duchamp appear mysterious and to place his work beyond critical judgement. One theme does emerge however: a loathing of art. In 1919 he defaced a cheap print of the *Mona Lisa* by drawing a moustache and goatee — the traditional attributes of the artist — on her face, and scrawling across the bottom the letters LHOOQ, which, when pronounced in French, read: '*Elle a chaud au cul*', which means, approximately, 'she's got a hot arse'. What Duchamp actually meant by this graffiti, no one, so far, has been able to determine, but whatever it means, it is not likely to be flattering to Leonardo or his sitter.

For his most famous attack on art, Duchamp chose the aspirant, rather earnest, provincial art scene of New York in 1917, not the sophisticated scene in Paris. When a well-meaning group of American artists formed a Society of Independents on the French model, in order to give artists outside the official groups a chance to show their work, they welcomed Duchamp, the radical Parisian, with open arms as one of its directors. There would be no jury and no censorship; any artist who paid their fee of six dollars could exhibit. Just before the show opened, Duchamp submitted six dollars

under the assumed name of R. Mutt, went round a builder's merchant, bought a urinal, signed it with his *nom de plume*, called it *Fountain* and submitted it as an exhibit. There was deception even in the *nom de plume*. It has been assumed that by choosing R. Mutt, Duchamp had selected a urinal made by J. L. Mott, the Rolls Royce of lavatory fixtures, but in fact the item he chose was a bog-standard one made by A. Y. Macdonald.

The committee were hurriedly convened in some confusion, most presumably thinking it was a practical joke. No one guessed that it was being played on them by one of their own directors, except for William Arensberg, the collector and friend of Duchamp, who was in on the jape. Arensberg defended *Fountain*, claiming that 'a lovely form has been revealed, freed from its functional purpose, therefore a man clearly has made an aesthetic contribution'. The committee took a democratic vote, and the exhibit was rejected. The press got to hear of it (Duchamp had whisked the reject round to the photographic studio of Alfred Stieglitz) and soon the whole of New York was buzzing. The Society of Independents issued a press release stating that the urinal was 'by no definition a work of art'. Duchamp replied, still anonymously, through the organ of *The Blind Man* (an aptly named pamphlet published in May 1917 by Duchamp himself with two friends): 'Whether Mr Mutt with his own hands made *Fountain* or not has no importance. He CHOSE it. He took an ordinary article of life, placed it so that its useful significance disappeared under the new title and point of view — created a new thought for the object'. No one knows exactly what happened to the urinal; it was presumably returned to its original purpose. The idea then that someone could have bought it as a work of art never entered anyone's heads. If they had been told that one of the world's leading museums would buy a replica made of it at the end of the century for nearly a million pounds, they would have thought the world, or at least the Tate, had gone mad.

The whole jape would have died a death if Duchamp had played his prank in Paris. There he would have been dismissed as just another joker in the pack. The humorist Alphonse Allais had shown, in the 'Incohérents' exhibition, a blank sheet of paper as a work of art as long ago as 1883. He entitled it *Anaemic Young Girls at their First Communion in the Snow* and was praised for his wit. But Duchamp was operating in America, where he

enjoyed the life of an exotic European fish in a small cultural pond, playing chess, advising collectors, and cultivating curators. When the Second World War closed Europe, and many artists fled to America, Duchamp was already there, with all the contacts, advising and manipulating. He was a close adviser to Peggy Guggenheim and it was he who, without a moment's hesitation and without consulting the artist, cut down the mural she had commissioned Pollock to paint for her apartment because, when it arrived, it was too big to fit into its allotted space. Duchamp never did care much for painting, nor for art, for that matter. He wrote: 'I'm afraid I'm an agnostic in art. I just do not believe in it with all its mystical trimmings. As a drug it is probably very useful for a number of people, very sedative, but as a religion it is not even as good as God'.

As Robert Hughes observed: 'By the late 1960s, Duchamp had risen to the stature, among younger artists, that Picasso had enjoyed in the 1940s. But there was an importance difference. Nobody at that time wanted to grapple with Picasso, but Duchamp opened up a small, distinct area of liberty to which scores of younger artists found themselves admitted ... the dandy's right to perfect a gesture on as small a scale as you wanted. ...Duchamp invented a new category of art "*infra-mince*" — it was occupied, for example, by the difference in weight of a clean shirt and the same shirt worn once'. David Hockney once remarked: 'It is a rather un-Duchampian thing to do to redo Duchamp'. The trouble is that, that is all you *can* do: repeat the concept. You cannot develop his language, as you could Cézanne's, if you were a Picasso, or van Gogh's, if you were a Matisse. Few artists wanted to grapple with Picasso in the late 1960s because few were painting — and certainly not painting in a way that was broad and rich enough to enable them to develop Picasso's language, let alone his subject matter.

There was one English art critic, however, who did his best to resist the decline in artistic content. Peter Fuller entered the debate as a Marxist in the 1970s, powerfully influenced by John Berger, though he ended teetering on the edge of Christianity, under the sway of John Ruskin. Ruskin was an odd figure for Fuller to cling to, though shifting from being a parasite to a saprophyte could be regarded as a step towards freedom. Ruskin was an artist and writer of genius who, himself, was clinging desperately to the belief that God had created the world in all its beauty for our delight and

edification, just at the very time when his contemporary, Charles Darwin, was proving that the plumage of peacocks had evolved over aeons to attract the attention of peahens, not to satisfy the aesthetic cravings of men. The passionate freshness of Ruskin's moral vision attracted Fuller, as it has so many, but it was extremely difficult to reconcile this with his Marxist materialism.

Ruskin believed that art is formed by and can help to form society. As a writer he was unusually successful in influencing both. The young William Holman Hunt had sat up all night reading his *Modern Painters* (1843–60), as if 'it had been written specially' for him. The whole, burning ambition of the Pre-Raphaelite Brotherhood was there, and the seed was sown that would flower in his painting *The Light of the World* (1851–53), perhaps the most famous man-made image in 19th-century Britain, when the light of the world was still God's light, not Darwin's. Nearly half a century later, most of the founding members of the Labour Party declared a debt to Ruskin's wonderful, short analysis of political economy, *Unto this Last* (1862), and Mahatma Gandhi sat up all night, on a train journey across South Africa, reading the same book. By the morning, much of his radical new political creed had taken shape in his mind. Nothing if not ambitious, Fuller founded his own magazine in 1988, calling it *Modern Painters* after Ruskin's great five-volume work, which started life as a defence of Turner, but ended attempting to change the world.

Fuller's new magazine began with a clear agenda: 'To uphold the critical imagination and the pursuit of quality in art' in the belief that 'good art can minister to the human spirit even in these troubled times'. In a godless society, Fuller felt, art cried out for some 'shared symbolic order' in which to take root and flourish. One gets the impression in Fuller's last writings that he was beginning to think that, without this order, art could never be great again. Had he lived, his *Modern Painters* might have shifted the tide of modern art, but Fuller was killed in a car crash in April 1990. There is no way, however, of telling where Fuller's thoughts were leading him. He might well have turned away from writing about art altogether. One of his last books was called *Images of God: the Consolation of Lost Illusions* (1985), and concludes with an essay about the historical Jesus, which barely mentions art at all.

It is one thing to want to change art, quite another to want to change society. As estate agents advise, buy in the right location, because it is easier to change your own property than it is the whole neighbourhood. That might be cynical, but it is also realistic. Apologists for modern art say we get the art we deserve. Modern art as we know it is produced almost exclusively in the richer, westernised societies of the world. These are increasingly materialistic, self-seeking and complacent about the fate of others who live in absolute poverty. Art, however, has always been on the side of trying to create a better world, even when it delves into the depths of the human psyche, as the Surrealists, at their best, did. André Breton's first *Surrealist Manifesto* of 1924 rings with optimism. It reads, in David Gascoyne's beautiful 1936 translation: 'I believe in the future transmutation of those two seemingly contradictory states, dream and reality, into a sort of ultimate reality, a super-reality'. By this Breton did not mean adopting a ' transcendental attitude', but expressing 'a desire to deepen the foundations of the real, to bring about an even clearer and at the same time ever more passionate consciousness of the world perceived by the senses. The whole evolution of surrealism, from its origins to the present day…shows that our unceasing wish, growing more urgent from day to day, has been at all costs to avoid considering a system of thought as refuge, to pursue our investigations with eyes wide open to their outside consequences, and to assure ourselves that the results of these investigations would be capable of facing the breath of the street'. In his second *Manifesto* (1929) he added: 'We must struggle against our fetters with all the energy of despair'.

There are two phrases here that could speak, like a clarion call, to artists today: 'the energy of despair' and 'the breath of the street'. To deny despair would be to limit art to a joy-ride. Yet to abandon the desire to communicate with one's fellow human beings in everyday life, not just with those in the art world, would be to resign oneself to despair, because if art does not make a positive contribution to society what is the point of making it? Society as a whole needs to select the art it values the most, but it cannot do this by voting (though the idea is intriguing) or even buying. So if democracy and market forces cannot do the choosing, who does it for us? Who are the selectors and the judges? And what motivates their selection of modern art?

73

Ceci n'est pas un objet d'art

This oak tree, this brick, this cast of a corpse found at Pompeii, this nail-clipping, this newt in formaldehyde, this photograph of the child-murderer and lover of Myra Hindley, Ian Brady, is not a work of art. Nor is it a pipe.

The Eclipse of Judgement

Since the emergence of the avant-garde, artists have seen themselves as a revolutionary force. Yet few are now fighting for the right to free expression or even social and racial equality, or religious tolerance, or a more equitable distribution of resources. Their battleground is now much more narcissistic. As Christos M. Joachimides put it in his introduction to the catalogue of *German Art in the Twentieth Century — Painting and Sculpture 1905–1985*: 'The interplay of art and life — the utopian notion of uniting the two — this is a theme which preoccupies artists, constantly engaging their minds and prompting them to experiment'. The usual reason given by artists for this is that they want to make art more relevant to life. But the way to achieve that connection is not to walk away from art, but to strengthen it. If you accept, as John Berger maintained, that a framed picture, especially one in a private home, cannot have much meaning to people today, then painting is truly doomed. This makes it easier to be persuaded that Tracey Emin's unmade bed does makes a statement of a kind — as a rebellion, though hardly an original one, against 'rising and shining'. This struggle to bring art closer to life, though widespread, overlooks the fact that the works of art in any era cannot help but reflect and be part of the life and times surrounding them. It is a question of degree: what proportion do you, the viewer, have to contribute to this encounter to make it meaningful or memorable or visually compelling, and how much are you given by the artist through the work of art?

The artist attempts to be the first arbiter in the decision about what is art and what is not by declaring that this elephant dropping or that bin-liner is a work of art. The artist is only successful in claiming something to be a work of art when, and if, a viewer responds to it as such. As L. S. Lowry remarked to a young artist who was complaining that no one bought his pictures: 'Well, no one asked you to paint them'. Even though we know that if artists did not create art today there would be no art to look at, this does not mean that the audience's opinion can be totally discounted.

Patronage can often inspire artists to greater heights, as happened time and again in the Renaissance. Artists generally have to set their own targets, but they often find it very stimulating to work on something that they know will be seen and judged by someone else. When David Frost asked Tracy Emin on his TV show why her bed was a work of art, she replied, 'Because I say it is'. He did not then ask her, as he could have done, 'But who says you're an artist?' Artists do not, by any means, hold all the cards; they are free to try to be artists, but others are also free to decide for themselves whether they have achieved their goal.

An obvious thing has happened, if one thinks about it: as artists have asserted that their life is their work, so the status of the work of art has fallen while that of the artist has risen. This has led to the perception of artists as modern-day shamen — divinely gifted individuals who turn everything they touch into art, and, if they strike lucky, gold. Artists themselves have become increasingly distanced from everyday life as their 'work' has become more integrated with it. One of the criteria used to select Turner Prize artists is the generalised 'contribution' they have made to art, and we are repeatedly assured that artists cannot be judged by individual pieces, but on their life's work in general. This is obfuscation: artists can only be as good as what they create. If only one painting by Vermeer had survived, we would recognise a great master. When Gombrich wrote that there was no such thing as art, only artists, he was trying to look freshly at what individual artists had achieved irrespective of the schools they belonged to. Today we have gone too far down the road of personality; now we need to focus much more on art and less on the artists who make it.

One of Joseph Beuys's most quoted sayings was that 'everyone is an artist'. This is a truism if it means that everyone has the potential to be an artist. Art is as unpredictable in its appearance as a mushroom; the mycelia from which it springs are myriad and hidden underground. But Beuys's glib saying is clearly untrue if one considers how most people spend their time. Yet 'even the act of peeling a potato,' Beuys opined, 'can be a work of art if it is a conscious act'. This is good news for cooks: they merely have to remind themselves of the task at their fingertips, and they can feel themselves to be Rembrandts. Would that liberating the masses from mindless drudgery were so easy! Even if you are persuaded that peeling a

potato can be a work of art, you have to accept that one work of art can be better than another. If you do not, how else do you explain the high prices collectors have paid for Beuys's art? We might all be artists, but some are more artists than others.

Joseph Beuys saw himself as a modern shaman, holding the key to the secret significance of the world around him. He left a trail of dried flowers, felt hats, sticks and fat, bones and blood, mud, sledges, stuffed animals, torches and toenail clippings in galleries of modern art around the world, as evidence of his passing presence. He told all those who gathered round him (he had a mournful charisma) that when he flew with the Luftwaffe during the Second World War, he was shot down over the Crimea. The plane crashed into deep snow, and Beuys recounted how his life had been saved by nomadic Tartars who wrapped him in felt and fat to keep him warm and nursed him back to health in their tents for several weeks, suggesting to him that, when he recovered, he left the air force and lived with them (an offer he unaccountably declined). This sequence of events became the central myth of his life, explaining and justifying the repeated use of felt and fat in his art works, performances and installations. The trouble is that it *was* a myth, or at least the best bits of it were.

It seems it is true that Beuys did fly in the Luftwaffe, as a radio operator and rear gunner, and his plane did crash in the Crimea. But the key ingredient of the myth around which his whole art was created is now thought by many to be make-believe. The German artist, Jörg Herold, took the trouble to visit the site of the crash and made a short video it for a show in his gallery in Berlin, Galerie EIGEN + ART, in 2002. He filmed the bleak, flat field where Beuys's Stuka crash-landed at 8.35 a.m. on 16 March 1944, and he interviewed local people who witnessed the event. Nikolai Lebilebitsch vividly remembered seeing the pilot, still strapped into the front seat, hanging down in mid-air, quite dead but with his pipe still gripped in his mouth. The radio operator, Beuys, had jumped clear and was standing in the barren field near the plane. He appeared to be all right, apart from a wound above his eye. The villagers and Beuys just looked at each other; they did not speak German and he did not speak Russian. Moreover he was the enemy and the villagers would have been afraid, during Stalin's time, to have any dealings with him, never mind

inviting him into their homes. They left Beuys to be picked up by the German troops who were searching the area for survivors of the fierce battle being fought on the eastern front. Military records suggest that he was picked up within hours, for he was admitted to a mobile military hospital on the next day, discharged on 7 April and sent back to frontline duty. There was, apparently, just one Tartar in the village though not a community of them. According to this research, there were no tents, felt and fat, and not one flake of snow.

Does this matter? Perhaps, such imaginative artifice only makes Beuys a greater artist. After all Henri Rousseau almost certainly made up the claim that he had been to the jungle while serving as a regimental bandsman in Mexico. But this invention is understandable: he probably blustered because he feared people would dismiss him as an ignorant amateur when a professional artist would only paint a forest after they had seen it and sketched it. Similarly, L. S. Lowry told everyone he had a private income when in fact he earned his living and, incidentally, found his original subject matter, as a rent collector. He pretended otherwise because he dreaded being dismissed as a Sunday painter. Rousseau's and Lowry's biographical fine tuning do not relate directly to the form or content of their paintings or diminish, in any way, their power. Seeing the sledge with a roll of felt and a lump of fat strapped to it that Beuys has installed does not carry any significant measure of expression until you know the story of Beuys lying unconscious, his life eddying away in the snow. Take away the biographical note accompanying the material and what is left? — a private visual symbol.

This is not to say that all Beuys's works lack any visual impact. For *Plight*, an installation gestated between 1958 and 1985, the artist lined the gallery walls with rolls of felt. In the middle of it stood a highly polished, black grand piano with its lid shut, as if silenced by the surrounding sound-proofing. There was something eloquent in that juxtaposition of shining and soft muteness, but it was a visual sensation that was not developed in his subsequent work. Even people who have heard of Joseph Beuys find it difficult to conjure up an image of one of his creations. He certainly did not create any works of art that caught the popular imagination. This is why his work is so little known among the public at large, in spite of the fact that he is allocated room after room in every major modern art collection around the world. At present, four galleries in Tate Modern are devoted to

his work, much more than to any other single artist. His reputation in the art world could not be higher. In the early 1980s, Beuys topped the list of living artists whose works were most valuable as investments. After his death in 1986 his major works continued to change hands for millions, and his multiple editions for hundreds of thousands of pounds — all this for what were essentially found objects and scribbled notes.

Carolyn Tisdall, the art critic and intimate friend of Beuys, wrote about the personal memorabilia that Beuys put into the vitrines now in Tate Modern: 'For him art extended to include life itself, history, nature, politics, music, which is why this collection refers to everything, bar art'. That virtually sums Beuys up: 'everything, bar art'. Picasso kept mementoes of his life, like Beuys, but he made a distinction between them and his works of art, including his assemblages of everyday objects. It would never have occurred to him to regard the former as works of art when he had done nothing to or with them. In her book *Life with Picasso*, Françoise Gilot describes how Picasso first met his previous lover, Dora Maar, at the Café des Deux Magots where he often dined: 'She was wearing black gloves with little pink flowers appliquéed on them. She took off the gloves and picked up a long, pointed knife, which she began to drive into the table between her outstretched fingers to see how close she could come to each finger without actually cutting herself. From time to time she missed by a tiny fraction of an inch and before she stopped playing with the knife, her hand was covered with blood. Pablo told me that was what made up his mind to interest himself in her. … He asked her to give him the gloves and he used to keep them in a vitrine at the Rue des Grands Augustins, along with other mementoes'. The complex feelings being enacted there, which so fascinated Picasso, found expression most fully in his paintings, such as *The Kiss* (1925), which must surely rank as one of the greatest, and still one of the fiercest works of art of the 20th century. If Picasso had been Beuys or Hirst he would have done nothing more than just exhibited Dora's gloves in the vitrine. There is a world of difference between Picasso's *Head of a Bull* (1943), made out of a bicycle saddle and handlebars, and the found objects seen in Beuys's work. In Picasso's assemblages, ordinary things are magically transformed to *look* like something else. In these works one can see visual creativity at its most exposed. Beuys's felt hat and nail clippings in his displays, remain just what they were in ordinary life.

But Beuys argued that it did not matter what these objects *looked* like, for his art was non-visual.

In 1986 Beuys described the revelation that had made him a 'sculptor', as he called himself. He had, or so he claimed, rescued a book of Wilhelm Lehmbrück's work from the flames of a Nazi bonfire before the war — an extraordinary act for a young man who had joined the Hitler Youth against his parents' wishes. Lehmbrück, a sad, turn-of-the-century figure in German art, committed suicide when he was only 38. His etiolated figurative sculptures (which look as if they have grown under stones, rather than out of them) repeatedly strike a chord of mournful, adolescent, sexual yearning. They were sufficiently unvaliant to merit inclusion in the Nazi's Degenerate Art exhibition of 1937. Beuys remembered that the illustrations of Lehmbrück's work, seemed to call out to him from the pyre: 'Sculpture — there's something to be done with sculpture. "Everything is sculpture", the picture more or less told me. And in the picture I saw a torch, I saw a flame and heard "Protect the Flame!"' Beuys goes on to describe what this flame was: Lehmbrück's sculpture, he believed, transcended Rodin's because 'Lehmbrück crosses a threshold in the concept of sculpture ... His sculptures cannot be grasped visually. They can be grasped only through an intuition that opens up completely different organs of perception; above all, hearing — hearing, thinking, willing. And this means that there are categories present in sculpture that were never present before'. What Beuys is claiming, by putting Lehmbrück's art on a higher pedestal than Rodin, is that art is progressing *away* from the visual. By implication, art that cannot be seen is best! But where does that leave the viewer? He is particularly at a loss when faced with Beuys's work. If he cannot trust the evidence of his eyes, nor what is written on the label, what grounds has he for making any assessment of the work of art he is looking at? Beuys was fond of saying: 'The aim of art is to make people free. Therefore art, for me, is the science of freedom'. But freedom from what? The freedom Beuys seeks is a freedom from critical reception. If that is the aim of his art (though it is a thin art indeed that has only one theme) then its very subject matter prevents us from judging how well he has achieved his goal.

The ascendancy of the artist over art has led directly to the disenfranchisement of the viewer. This is the opposite of what, we are

assured, is supposed to be happening. We are told that the assemblages and installations of everyday objects in art galleries can mean anything we want them to mean. This is sold to us as audience participation, when in fact it is audience exclusion because we can never tell what the person who put them there wanted us to think and feel. In the end, no contact is made. Take, for example, Damien Hirst's musings on a cigarette: 'The whole smoking thing is like a mini life cycle. For me the cigarette can stand for life. The packet with its possible cigarettes stands for birth. The lighter can signify God, who'd give life to the whole situation. The ashtray represents death, but as soon as you read it like that you feel ridiculous. Because being metaphorical is ridiculous but it's unavoidable'. This sort of random association is impossible when contemplating a work of art, no matter how elusive and suggestive its content, because the meaning of a work of art is locked into it in the process of its creation. This gives true works of art the power to say so much more than objects lifted out of life or than works which are dependent on a non-intrinsic biographical context for their meaning.

Andy Warhol made a virtue out of the anonymity of his works of art — most of which, in any case, were manufactured by the assistants in his 'Factory', the name he gave to his studio. His replicas of Brillo boxes and pictures of soup cans are so bland that his part in their making is virtually unidentifiable. His films, mostly depicting the lost souls who gathered round him like flies to fly-paper, look as though he has left the camera running and gone to sleep for several hours (as anyone does who watches them after the initial keyhole fascination has worn off). There is an irony here, because the more self-effacing Warhol became, the more his fame grew. Beuys claimed that everyone was an artist; Warhol that 'everyone has their fifteen minutes of fame'. Warhol began his career as a commercial artist: he won a medal for his highly polished shoe adverts in 1957. As time passes he will be remembered as a bizarre character in the post-war consumer boom. As for his art, only his screen prints of Marilyn Monroe, executed with surprising verve in a highly original, often plaintive palette, will survive as evidence of his response to an even more famous and much more tragic, more talented yet no less painted life. Not all of Warhol's work is empty of meaning, despite his best efforts to make it so.

Arthur C. Danto, the philosopher, was bowled over by Andy Warhol's *Brillo Boxes* (1964) when he saw them for the first time stacked in a gallery in New York in 1964, not for their merit as works of art (that, for him, was only a question of relativity) but for the philosophical question they raised. How could replicas of Brillo boxes be seen to be works of art in one place when they would be taken for boxes of soap pads in another? Danto dismissed earlier philosophies of art as being really only art criticism. For Danto, 'Nothing is an artwork without an interpretation that constitutes it as such'. The problem with this approach is that judgement is thrown out of the window. Once something is accepted within the sacred circle of art, it has to be treated with equal respect. So Professor Cynthia A. Freeland, a follower of Danto, seriously equates Goya's great late painting showing *Satan Devouring One of His Sons* (1820) with Andres Serrano's *Piss Christ* (1987), a large coloured photograph of a crucifix seen from the side, floating in a halo of golden light, showered with urine. The problem is that this comparison belittles the former and ludicrously inflates the latter. Goya's painting is a profoundly disturbing image of great psychological depth; Serrano's image is merely trivial sensationalism. Freedland accepts Serrano's justification of his work as a criticism that contemporary culture is commercialising and cheapening Christianity. If that was the point he was making, why did Serrano have to pour urine on this image of Christ? Pouring molten metal would have done the job much better, though it probably would not have caused the same international outrage.

It is too easy to offend public mores by being lavatorial, or sexually explicit, or attacking someone's religious beliefs, or, most fundamentally, by being disrespectful to the dead. The furore raised in America by Robert Mapplethorpe's elaborately posed photographs, such as his *Jim and Tom, Sausalito* (1977) which showed one man urinating into another man's mouth (a storm which led to demands for the reduction of public spending on the arts) was all about the laws of decency not the merits of Mapplethorpe's art. In this atmosphere it became difficult to assess his work seriously: his photographs do have a somewhat melodramatic intensity, whether they show flowers or erect penises. Apart from Robert Hughes, there is no one today writing with critical authority both within and without the art world, as John Berger and to a lesser extent, Peter Fuller did two decades ago. Julian Stallabrass in his intelligent book on the work of young

British artists in the 1990s, entitled, confusingly, *High Art Lite*, maintains that 'to praise or criticise' the work of these artists seems 'as pointless as judging the weather'. He betrays, however, a sneaking suspicion that 'to make no judgement is to accept complicity' with an art that might be only 'lite' after all — hence his title. Instead of berating the absence of serious art criticism, Stallabrass joins those who believe that judging art is 'like publicly and authoritatively announcing what flavour of ice cream you like'. He could have bellowed from the rooftops that taste is not judgement.

Apologists for modern art often justify its eagerness to shock by claiming that it is merely a by-product of one of its central purposes, breaking down the barriers between art and life. Shock is also often a method of deflecting any serious critical assessment of what the artist has actually achieved. A shock, after all, brings with it a temporary suspension of judgement, which is why it is such a good tactic of war. This is one reason why artists claiming to be radical today often make images that are virtually impossible to look at. Not many can look for more than a fraction of a second without feeling sick, at Hirst's *A Thousand Years* (1990), containing a rotting cow's head being eaten by flies. That work was bought by Charles Saatchi and included in an exhibition of his collection, called *Sensation*, held in the august rooms of the Royal Academy in 1997. Also included was a huge 'painting' of a blown-up, newspaper photograph of the child murderer Myra Hindley (*Myra* [1995]), in which the printing dots in the original image had been replaced by stamped imprints made from the cast of a real child's hand. Winnie Johnson, the mother of one of the children whom Hindley and her lover Ian Brady had tortured and killed, stood sadly outside the Royal Academy trying, vainly for the most part, to persuade people not to buy an entrance ticket for the show. The painter Craigie Aitchison and the sculptor Michael Sandle resigned from the Royal Academy in protest at the Academy's refusal to respond to her plea to have the painting removed. Sandle commented sadly: 'We have left the realm of art now'. Marcus Harvey, the maker of the exhibit, was quoted in the press as saying that he regarded Hindley as the 'Love Goddess, who secretly, secretly, in our heart of hearts, we all want to shag'.

If one does not know that it is Hindley, the image — merely a vastly enlarged mechanical reproduction of an unprepossessing woman — is boring, and the substitution of handprints for dots visually tedious. If you

do know it is Hindley, and know what she did, then the image does not become any more compelling to look at, but the substitution of children's hand prints becomes sickening, especially when you realise that they appear to be caressing the woman's face. You can, however, discount this second response because it is entirely dependent on the knowledge you yourself bring to the image and not inherent within it. Is not all this merely art exploiting life, and in the case of *Myra*, terrible suffering? If art *were* exploiting life, what has art or life gained by the process? What has Harvey added to our understanding of suffering by making this piece? Or, if that was not his intention, despite his choice of subject, what has he added to the world of artistic vocabulary or expression? It is the difference between being moved by a routine, manufactured crucifix you can buy in a shop selling Christian artefacts and the great image of Christ, bleeding and in agony, painted in 1510 by Grünewald. If you are a Christian you can be moved greatly by both, though probably more so by the latter. If you are an atheist the painting could still move you profoundly even if the ordinary little crucifix will leave you cold. The latter is a great work of art, an extraordinary gift by Grünewald to humanity as a whole. *Myra* falls into the former category, because it gives the viewer nothing he or she does not bring to the encounter, except perhaps for that sensation of caressing a murderer's face.

The *Sensation* exhibition could just as easily have been called *Sensationalism*, and taken its place among all the other 'isms' in modern art, because another reason for shocking someone else is to draw attention to oneself. In 1991, Damien Hirst created an 'art work' by having his photograph taken posing next to the decapitated head of a corpse in a morgue. When this work was shown on television, the dead man was recognised by his relatives. They were upset, not least because the artist was grinning broadly. In 1983, Luciano Benetton, head of the fashion chain that bears his name, appointed Oliviero Toscani to sell the brand. The images he used made Benetton the byword for shock tactics in advertising: photographs of an Aids patient on the point of death, copulating horses, the bloodied clothing of a victim of the Bosnian war, and models dressed as a priest and a nun kissing (the Vatican complained about that one). The campaign finally over-stretched itself in the USA when Benetton launched a series of huge photographs of portraits of murderers on death row to

sell jumpers. The parents of a victim of one of the killers, who had first abducted, raped and tortured their son, started a petition against Benetton. Could it be that at the cynical end of self-publicity, it does not matter what people are talking about as long as they're talking about you? In the media whirlwind that modern art has become, the focus is on the personality of the artist, not on what he or she actually does to merit one's attention.

The antics of salesmanship, not to say performance art, are not new. Mark Twain creates a wonderful episode in which Huck Finn falls in with a mountebank, who tells him to stick up posters around the town announcing a shock-horror, men-only show. Huck does so, and takes the money as the men pour in. When the theatre is full, the curtain opens and the mountebank crawls onto the stage on all fours, totally naked but 'painted all over, ring-streaked-and-striped, all sorts of colours, as splendid as a rainbow', capers about a bit, and quits. The next day he tells Huck to put the posters up again. Huck is naturally reluctant to do so, but the mountebank tells him that he knows what he is doing: the men will not admit to having been conned, but will have told all their friends to see the show, to get them duped, too. On the next night the theatre is full again and the show is as brief as before. Huck pleads with the mountebank to get out of town fast, but he again tells him to put up the posters, assuring Huck once more that he knows what he is doing. Huck goes round the town, trembling with fear. That night the men all arrive and buy their tickets, but this time their pockets are bulging with all manner of weaponry. When the house is full, and the curtain is still shut, the mountebank appears at Huck's elbow, fully clothed, and says, 'Now's the time to run'.

Many have criticised every new development in modern art as being that kind of con. A conman is someone who convinces the buyer that he is getting more for his money than he in fact is. What is impressive about Hirst is that his clients *do* get what they see, and come to value it (though how anyone can pay tens of thousands of pounds for the privilege of being able to look at the fly-infested, suppurating, decapitated head of a cow, again and again and again, in the privacy of their own room seems, at least to me, beyond reason). That is not a confidence trick, but one has to admit it is very good salesmanship. It cost a lot, however, to have these installations made, particularly the ones in formaldehyde, and in 1995,

Hirst came up with a new creative line. His Spin Paintings were circular canvases on which household paints were flung while they were spinning. Hirst saw the technique demonstrated on the popular children's TV programme, *Blue Peter*. He was delighted because, as he said, 'You can't make a bad one'. It appears that Hirst's assistants make them; he looks at them afterwards, seals them with his approval and adds their lugubrious titles. They sell for tens of thousands of pounds each; the National Galleries of Scotland have just bought one. With remarkable naivety for a government accused on every front of 'spin', one of these 'paintings', called *beautiful, all round, lovely day, big toys for big boys, Frank and Lorna, when we are no longer young* (1996) was used on the front cover of a book *Creative Britain* written in 1998 by Chris Smith, the Secretary of State for Culture, Media and Sport.

Britain, or more accurately London, came to be regarded as the world capitol of the visual arts in the 1990s. To appreciate how and why this happened, one needs to understand how an art world can be created by a tiny handful of people in powerful positions. All you need is an artist to make the work, someone to exhibit it, someone to promote it and sell it — though not necessarily in that order. The public at large need not take part in this process at all. There are no market charts in the visual arts, as there are for books and discs; nor are attendance figures at exhibitions a useful indicator of public acclaim. Only people with a vested interest in the visual arts attend exhibitions in dealer's galleries where most artists' reputations are made, and they go in handfuls, not hundreds. The *Sensation* exhibition at the Royal Academy was mounted after seven years of intensive publicity, and even then only attracted 300,000, a third of the number drawn to a major Impressionists' show. A small development in the art world can easily be inflated out of all proportion if its backers are well placed. This is exactly what happened in London during the early 1990s. The take-over would not have been possible in America, where the art scene is more diverse, rich collectors are many and widely dispersed and tastes differ greatly from coast to coast. But in London, there was one very big fish in a comparatively small pond.

Charles Saatchi exerted great influence from the 1980s onwards simply by becoming by far the biggest buyer, exhibitor and promoter of modern art. His marketing and advertising company, M&C Saatchi, was by then

one of the largest in the world. By the mid-1980s, he began spending about a million pounds a year on contemporary art. He could match the Tate in buying power and easily outbid it if he so wished. He turned an old paint depot in North London into a privately run gallery open to the public; it was three times the size of the Whitechapel Art Gallery, the main alternative contemporary art space in London. The result is that, for decades now, aspirant artists have tried to produce art that will catch Saatchi's eye. The assumption, currently, is that he wants to be shocked. Chris Ofili, who enjoyed a brief period of notoriety for adhering dried elephant dung droppings to his pictures, and whose work is in the Saatchi collection, was by cited Joanna Pitman in the *Times* on 23 September 1997, as saying: 'A lot of artists are producing what is known as Saatchi art ... you know it's Saatchi art because it's one-off shockers. And these artists are getting cynical. Some of them with works already in his collection produce half-hearted crap knowing he'll take it off their hands. And he does'.

Saatchi has increasingly become identified with the work of Damien Hirst. In the late 1980s Hirst was more of an artistic entrepreneur than an artist. He had not yet developed his creative line, though he appears to have been determined that when he did he wanted to be famous as well. He and his fellow students at Goldsmiths' College decided not to wait until the art world deigned to notice them but put on a show, in a disused warehouse in South London, and invited the leading dealers, curators and journalist to come to them. The called the show *Freeze*. Many students had put on similar shows in disused factory spaces in the past, but Hirst was more thorough than most at raising sponsorship to get the place renovated. If the denizens of the art world did not come he did his best to go and get them, personally driving Norman Rosenthal, the head of exhibitions at the Royal Academy, down to see the show. Eight years later, Rosenthal admitted that he was not over-impressed at the time, yet wrote in his introduction to the exhibition *Sensation: Young British Artists from the Saatchi Collection*, that this art was now taking the whole world by storm, adding that he wished he had bought some pieces from *Freeze* at the time.

It is difficult to write about these young artists' works in any coherent way because they share no common artistic language. A beautiful, hand-lettered panel of 1901 by the Scottish architect and artist, Charles Rennie

Mackintosh reads: 'There is hope in honest error none in the icy perfections of the mere stylist'. It could stands as a condemnation of so much Britpack art. In 1991, Damien Hirst had rows of large, exotic seashells decoratively arranged on shelves in a showcase. He called the ensemble *Forms without Life*. He was right; they are forms without life. To be avant-garde the Britpack had, of course, to attack the art of the recent past. So Angela Bullock in *Mud Slinger* (1993) used a spray gun to sling mud at a wall, mocking Richard Long, while Glen Brown, with unbelievable tediousness, painted photographs of paintings by Frank Auerbach, all their impasto reduced to a smooth illusionist finish. Sarah Lucas's work is slightly different, however; she shows the beginnings of visual creativity. She took a photo of herself eating a banana, and was intrigued by the sexual innuendo (hardly original, but at least visual and not totally pat). She says that her mind is full of 'bits and pieces of ideas – things I have been thinking about for years' and that these emerge as she works. This is how any artist creates: the problem is that Lucas is hamstrung by the fashion for using only found objects, so she cannot explore these thoughts and feelings with much subtlety or profundity. They remain one-liners, like *Au Naturel* (1994): a couple lying on a mattress, personified by arrangements of two melons with a bucket, and a cucumber with two oranges. The fruit has to be replaced frequently, lest it sag or droop. Hirst has commented that there is 'something missing' in Lucas's work. Lucas's art is different because it has the possibility of honest error. What is missing from it is the clinical cynicism so evident in the products of the rest of Britpack art. Few visual experiences could be icier than looking at one of the life-size paintings, in magnolia gloss paint, of a door painted in magnolia gloss which Gary Hume made his name producing in 1989. Icy is too nice a word: ice can be refreshing, and melt on contact. Hume's doors, to nowhere, are arid; their immaculate conception is totally pain-free because nothing is being born.

In many ways Hirst and his fellow students were lucky. The art world was beginning to suffer from the recession of 1989–90, which saw a lot of dealers go under, and the survivors were looking round eagerly for 'the next thing'. The speed with which the artists in *Freeze* were picked up by Saatchi and a handful of leading commercial galleries suggests desperation rather than the happy coincidence of independent judgement converging on a set

of students, among thousands, from a single art school. There is nothing intrinsically wrong with this process. Artists want to sell their work and dealers enable them to do so. This market, in its upper echelons, is a particularly exclusive one. Art galleries, as people in the trade tend to call their retail outlets, are not like other shops. They do not set out to sell what they are already fairly certain people want to buy but, rather, try to create a market for the art that they want to sell. Even those dealers who are more interested in art than money — either because they have the financial backing to be able to, or enjoy living dangerously — are not in the business to promote art for the public. Once the dealer has selected what they call their 'stable' of artists — the associations with class and cash, not to mention the concept of the thoroughbred, are never far from the art dealer's world — their job is to make them winners. They do this by excluding other art from being seen near their chosen few, if they can, to clear their path for victory. Few hopeful artists who tour the private galleries in our major cities, clutching their portfolios, realise that the job of the debutante at the desk is to drive them, as sweetly as possible, away. The contemprary art that is sieved out by this private dealer system is not automatically bad — much of it is good (market forces can work well in art as elsewhere) but it does, of necessity, provide only a narrow, gilt-edged view of all the art that is being made today. The public need to get a broader view of contemporary visual creativity.

This wider canvas used to be provided by the public gallery system. The job of the art curator was to look at the work of those artists who had dealers and the many who did not, as part of an on-going search for art of lasting merit. Public art galleries and art museums added to the scene; they did not just show the art that dealers sold. But the public galleries' ability to do this has diminished as their core funding has been cut back. If they do attract increased funds they tend to spend this on fund raising, marketing and management staff, and these posts have grown hugely as the numbers of curators have decreased. Increasingly art museums around the world have become tied to the apron strings of the art market, quite simply because the richer dealers, especially those with wealthy clients, can help sponsor shows that fill otherwise empty exhibition programmes. The relationship between the art market and public art has always been closest

in America, where private collectors have traditionally had a key say in museum purchases. It can be difficult for a curator to express the view that, say, a recent work is no good, if the chairman of his board has just bought one, and a curator might even be persuaded to accept such work for his collection, if it is offered free as a tax break by his chairman — especially if this individual is also willing to pay for a gallery extension! Artistic judgement can never be totally independent, especially in a mixed economy, nor would one want it to be isolated from contemporary concerns. But the only way that the public's interest in art can be properly protected and served is by curators actively and disinterestedly seeking the best art they can find. Today's curators, however, have ceased to be the public's representatives at the court of art; instead they have become at best artists' agents, at worst dealers' foot soldiers.

The main job of the Tate Gallery, surely, is to select the art of our times that needs to be preserved for present and future public benefit. However, the relationship between the main public art galleries and the art market, dominated by one man, became confusingly closed to any outside observer in London in the 1980s and 1990s. In 1982, the Tate mounted an exhibition consisting almost entirely of Charles Saatchi's collection of Julian Schnabel's paintings. This exhibition diminished the Tate's reputation for independent judgement in several crucial ways. Had the Tate genuinely believed that all the critics at the time, from Robert Hughes to Peter Fuller, were wrong and that Schnabel's work was on a par with the other great masters of recent times, it could merely have hung a Schnabel or two among them to make the point. But it gave Schnabel the exceptional honour of a one-man show, despite the fact that many thought at the time that Schnabel's reputation was a confection of the American art market. In the 1980s the American economy was booming. With cash to spare, hundreds of the new rich, many of them young, wanted to find something to spend their money on, and Schnabel became just a more successful Byron Browne. To counteract the criticism that they were merely helping to promote a market fashion, the Tate needed to have shown a retrospective of Schnabel's work to date, to demonstrate how his work had developed into the great flowering of creativity the Tate believed it was. It is standard curatorial practice that all works of art shown in a gallery are

rigorously selected to ensure that quality is sustained. In this case, the Tate did not even attempt to select the best of this artist's highly prolific output, but instead showed almost exclusively what just one collector, Charles Saatchi, had bought. The fact that Saatchi sold his Schnabels a few years later left a question mark hanging over the Tate's judgement at that time.

Gertrude Stein thought that the very idea of a museum of modern art was a contradiction in terms, and she said so when the idea to form one was being mooted in New York in the 1920s. Jean Tinguely considered museums to be the death of art; modern art, he believed, needed to be in the street, and that is where he, exceptionally, managed to create great works of art. One of the results of the widespread desire of artists to break down the barriers between art and life was a burgeoning of happenings (later called performances) in public places — the aesthetic equivalent of streaking and busking. But it's tough work attracting attention in the market place; it's much easier to do the reverse, take life into the art galleries, where a found object out of context can attract attention. Both these operations, taking art out the gallery into the streets and bringing life outside art into the gallery, deny art its special place in society. There is nothing wrong with art in art galleries! Not much art is actually robust enough to survive in the rough and tumble of a public place, both physically and aesthetically; much of it is more intimate and needs the environment of a gallery to be fully appreciated, just as much modern drama and music require theatres and concert halls. If museums and galleries of modern art did not exist, then much modern art would remain for private consumption only, and we would all be the poorer. Public galleries, then, have an absolutely crucial role to play in promoting contemporary art. Without them, most people would not see modern art at all. The onus is on the public gallery curators to select art which they think is profound and lasting, and therefore worthy of public attention. They have to take a fresh view, from their own independent standpoint, and explore new ground, not merely serve as mouthpieces for powerful dealers or collectors nor, for that matter, artists who are particularly good at self-promotion.

However curators have found it increasingly difficult to resist the demands of the artists, as their personalities and views have gained increasing ascendancy over their works. Sir Nicholas Serota, the current

director of the Tate, is one of many modern art curators who argue that this ascendancy should *not* be resisted. In his lecture, *Experience or Interpretation, The Dilemma of Museums of Modern Art* (1996), Serota made the case for a redefinition of the curator's role: 'No longer can the curator be seen solely as the dispassionate judge of quality, who visits the studio or private collection to select works and to assemble a body of material which will be presented to the public in the museum. Instead the curator is a collaborator, often engaging with the artist to accomplish the work'. Serota outlines what he regards as the standard 'new convention for the presentation of contemporary art' as giving 'absolute weight to the work of individual artists', favouring 'presentation over analysis', and hence undermining 'the traditional priority given to the curator as the person who exercises discriminatory judgement over selection and display in the museum' so that 'traditional museum disciplines of juxtaposition, analysis and interpretation can be reduced to a minimum'. He adds, finally, that 'experience is paramount', the experience, that is, that the visitor gains from the museum as a whole, not just from individual works of art. This is exactly the same drift we have seen away from the work of art towards the artist. In the museum, it is a movement away from the self-contained exhibit towards the whole environment. This visual environment is still totally controlled in the museum, as it used to be within individual works of art, but now the curator is a partner in the creative process. Previously, curators could hang paintings on walls and put sculptures on plinths and let them do their work. They had no part in their making, nor in their communicating, except to choose them well and to hang them well. But today much modern art needs art galleries to exist. Curators have found this rather flattering and have come to see themselves as having a creative role to play alongside the artist in the presentation of art. Thus the whole museum becomes the installation.

Serota traces the origin of installation art to painting itself, beginning with Matisse's great painting *Red Studio* (1911), and then via Mondrian's studio, which Serota argues was itself a work of art, through Kurt Schwitter's *Merzbau* (1923–) to Duchamp's *Etant donnés* (1946–66). He argues that the art of painting, not wishing to be confined to representation, or to abstract decoration for a room, itself wanted to occupy three-dimensional space.

This is tantamount to saying that painting killed itself off. Was that really what Matisse was trying to do? His *Red Studio* is a wonderful expression of the notion that a god of love, were such a one to exist, could most convincingly take the form of space itself which floods through everything. The son of Matisse, in that sense, is Hockney, who has never stopped playing with ideas of space, but not with space itself. That would be like playing god, which is exactly what installation artists, aided by creative curators, do when they take over the public space in an art gallery, and like all gods they do not like other gods sharing their space.

In 1972, the director of the Solomon R. Guggenheim Museum in New York allowed the French artist Daniel Buren to leave his *Painting Sculpture* (1971) (which consisted solely of a length of white and blue striped canvas) hanging from the centre of the dome for one week without anything else on show in the gallery. Buren had complained that the other exhibits in the *VI Guggenheim International* had prevented the public seeing his contribution in the way he wanted — hence his battle with the director and the demand for an exclusive extension. Buren was one of the earliest installation artists. His stripes have now been seen in over a thousand locations around the world, most famously on the truncated pillars that disturb the serenity of the courtyard of the Palais-Royal in Paris. They are always the same stripes, in even bands like the awning canvas that inspired them, though the colours vary. They purposely have no apparent content. Buren said 'all art is reactionary', including, presumably, his own. Nevertheless he won his battle and curators now generally accept that two installations cannot share the same space. The direct result of this is that art museums today show the work of fewer artists than ever before. This represents in itself a diminution of choice and explains why so many visitors to modern galleries complain about how little there is to see. Serota argues that the public benefits from this reduction by being given more intense artistic experiences. But is not it also the job of a museum to provide its visitors with opportunities to develop their critical judgement by comparing the achievements of artists with their contemporaries and predecessors? The collusion of the museum with the artist to create a total immersion, or a totally contemporary experience, mitigates against learning in this way. But is this not an illusion, and an odd one for a museum to adopt? Of

course a work of art needs to be given an unhindered viewing, but it also needs to be put into context, otherwise there can be no critical judgement.

Chronological displays, putting the exhibits into a historical context, have now virtually disappeared from modern art galleries around the world. The justification for this is that the modernist conception of a step-by-step avant-garde progression is no longer tenable or convincing. Nevertheless the moment we walk into the first displays in Tate Modern we are informed that: 'The story of modern art is inextricably bound up with the story of the avant-garde,' which means for the Tate, 'art that breaks with the past, takes a critical look at the present and proposes a radical future'. But we are never given a chance to assess for ourselves what this avant-garde actually achieved, what art they were reacting against, nor how they changed their concerns over time, eventually, like Orwell's pigs, turning into the establishment themselves. Instead we are provided with a lucky dip of ahistorical themes. In a section called 'Landscape', Monet's great *Waterlilies*, painted some time after 1916, is hung on a wall next to Richard Long's floor arrangement, *Red Slate Circle* made in 1988. The label tells us that 'both artists convey a sense of immersion in landscape through their intense observation of nature'. How can that phrase 'intense observation' be used to describe, on the one hand, the attention of one of the world's greatest landscape painters, and, on the other hand, an artist who finds bits of rock and places them in a gallery? A comparison could, however, be made between these two works showing how attitudes towards nature changed dramatically during the decades that separated their creation. Richard Long's work can only be fully understood within the context of the burgeoning ecological movement. Monet's painting was created before such issues were of general concern; it is about, among many things, an old man, who loved looking at things, losing his sight. The Monet looks drab and unloved in Tate Modern; it has lost the sparkle it used to have when it was hanging in the National Gallery. So substantially had the art of painting fallen from its position of eminence by the 1990s, that Tate Modern was not designed to show it, as it would have been only a decade or so earlier. Its galleries are all-purpose, artificially lit black boxes, ideally designed to show installations and videos. They do not have windows in

the roof which would wash the walls evenly with natural light — the ideal lighting for looking at paintings. The Monet should not be there at all.

In 1998, the Trustees of the Tate persuaded those of the National Gallery to change the farsighted policy of that gallery's founders, which had been to establish a gallery that would collect together the greatest paintings in the world as they emerged over time. This was a policy they had pursued with outstanding success from 1824, making the National Gallery, arguably, the greatest gallery in the world dedicated to the art of painting. That policy has now been stopped. Though the National Gallery itself acquired van Gogh's *Sunflowers* in 1924, a mere 36 years after it was painted and Degas's great *Combing the Hair* (interestingly from Matisse) in 1936 only 40 years after the artist stopped working on it, it would be unrealistic to assume such prescience on a regular basis. There was, therefore, an agreement between the National Gallery and the Tate that the former would take paintings from the latter if, over time, they were seen to have acquired sufficient status to hang in the National Gallery's illustrious company. No more than a couple of paintings earned this accolade in a decade. Not that even this double-handed approach was foolproof: neither the National Gallery nor the Tate managed to collect a great painting by Matisse, though this artist produced more than his fair share of masterpieces. How much better it would be for the National Gallery today to concentrate on acquiring the future Matisses, not clogging up its walls, as it is now doing, with overpriced minor old masters, as they are obliged to do now that their collection is closed at 1900 — the date John Berger first proposed for the death of painting. The National Gallery needs to go on collecting great paintings simply because artists have not stopped painting them. But in our times, this great, growing museum of art has been surreptitiously suffocated. On the line of totality, which ran directly through London, when the language and learning, meaning and judgement of art all virtually ceased to exist, the shadow of the eclipse reached back into art's past and as far as we could see into its future. However, nothing is permanent; the shadow is passing.

David Kemp, *The Old Transformers*: *Iron Master* and *Miner*, 1990.
Relics of the last Iron Age, Leadgate, County Durham.

The Passing of the Eclipse

The very concept of art has been so brutalised in recent years that it is difficult to see how it can survive, let alone revive. Without a widely accepted understanding of what we mean by art, what chance has it to regenerate? The task we face is to clarify what qualities distinguish a genuine work of art from the ersatz products of today. The quality that links the paintings of Vermeer and Matisse, Grünewald and Picasso, and that earns them the status of works of art — a status few would deny them — is, I would suggest, the aesthetic light that appears to shine out from them. At a mundane level, of course, the light in them is not the same. The gentle daylight streaming through the leaded window in a Vermeer is not the sunlight pouring through the shutters on Matisse's Mediterranean balcony, though both artists painted light in rooms. The spiritual intensity that illuminates a Grünewald is not the same as the sensual passion that radiates through a Picasso, though both artists depicted light and dark locked in battle. On an aesthetic plane, however, these artist's paintings all have that quality of light that distinguishes a work of art. It exists, of course, only in the mind of the spectator, though it is no less real because of that. Though we can never be certain that our experiences of art are the same as anyone else's (and they will certainly never be exactly the same), evidence of responses to art across the centuries suggest that works of art can have very similar effects on very different people. There must be something real here. Difficult though it may be, it is worth trying to get closer to what we mean by 'aesthetic light', because it is this light that will re-emerge after the eclipse has passed.

Any work of art worthy of the name has an instantaneous (perhaps a better word would be simultaneous) effect on first viewing. An artist might bring all sorts of feelings and thoughts into play, yet unless he or she manages to make them all contribute to one encompassing, illuminating whole, the work of art will have no heart, no 'life' of its own. But a work of art cannot come to life. The life in a work of art is, therefore, triggered

in ourselves, not in the object before us. Looking at a great work of art makes one feel more fully aware of one's thoughts yet no longer wearied by them, more exposed to one's emotions yet no longer drained by them, more integrated, more composed — more, in a word, conscious. It is the light of consciousness that great works of art ignite in our minds — consciousness, the nature of which, even the reason for which, scientists have not yet been able to define or explain. All great works of art share this quality, whatever aspect of experience they explore. It is this quality of luminosity that unites the divine visions of Piero della Francesca with the nightmares of Goya. We enter their worlds of radiant lightness and unfathomable darkness in a similar state of heightened awareness. This is the light of conscious imagination that will return to art after the eclipse has passed.

A found object, whether it is a brick or a urinal, cannot by itself inspire you with a heightened level of consciousness, just because it is selected and placed in a gallery. You can look at these things with a heightened consciousness, certainly, but you can never know, just by looking at them, if you are sharing the artist's consciousness of these things. The man who designed the urinal (I am assuming it was a man) did not make it to inspire ideas about art, but for men to urinate into. We can admire, if we are so inclined, the achievement of his aim. Yet how can we ever really know what was in Duchamp's mind when he put it in the gallery? There is too much of a gap between his consciousness and ours for conjecture. We can make a good guess at what was going on in Carl Andre's mind when he arranged his bricks on the floor, and in Rachel Whiteread's when she cast her *House* (1993), yet we cannot be sure because they have left no trace on the objects they placed or cast that indicates their thoughts or feelings. What imaginative light emanates from Whiteread's *House*? It had, it is true, a mournful presence (it was demolished shortly after its manufacture for safety reasons), but this effect was due to its context, rather than anything inherent in its form. It was the cast of the inside of one terrace house in a row that was being demolished. When all the bricks and mortar, windows and roofs of the row had been removed, the cast was left standing there in the vacant lot like a pale, abandoned ghost — a death mask of the interior of a house. One could feel sorry for it, but this was essentially a

sentimental response, which depended on the feelings one brought to this encounter. These would have been very different if you had been told that a murder had been committed in those very rooms. All artists try to make statements that transcend private associations: that is what art is — an unconditional gift to others. The greater the art is the more detached it becomes from private meanings or small social circles, and the more freely it stands as its own interpreter, to speak to all of humankind. Found objects and casts of found objects are detached from their perpetrators, though in an unhelpful, ungenerous way, because they have never been part of the artist in the first place. They short-circuit the making of art; they are borrowed, not born. They are not images wrought out of feelings and thoughts and crystallized into consciousness. By this criteria *House* does not, therefore, even begin to be a work of art.

One comparison will suffice, I hope, to clarify the tremendous difference in potential that lies between totally creating one's own image and using a found object. First I need to describe to you a painting by Alexander Guy, called *Crib VII* (1992). It is a life-size depiction of an old-fashioned, wooden baby's cot, with drop bars at the side for getting the baby easily in and out and changing the mattress as required. Guy has painted the cot boldly in creams, outlined in black, but instead of a soft mattress on the bottom, the artist has painted a bed of fierce spikes. Now I need to ask you to imagine a work by Mona Hatoum called *Incommunicado* created a year after Guy painted his picture, in 1993. This is a modified found object. It consists of a real cot — a institutionalised, metallic one found in a maternity hospital — standing on the gallery floor. It looks just like an ordinary cot, until you notice that the artist has replaced the comforting bed of springs with a rack of cheese-wires pulled tight. Both artists have come up with similar images, though as a result of having worked in very different ways.

Alexander Guy had studied painting in Scotland, where older studio traditions lasted longer than in England. The subject for his uncompromising art is distilled from his personal experiences and thoughts. He once attended a wedding at which a blood-stained sheet, proving the bride's virginity, was shown to the approving guests. This led to a series of paintings of human irons, chastity belts and man-traps. As Guy wryly commented: 'If Mary had slept with Joseph and lost her virginity, instead of a night of passion

with God, then life would have been a lot simpler for everyone, especially women, over the last 2000 years'. Mona Hatoum was brought up in Beirut, but moved to Britain after the outbreak of civil war in 1975. As a student she was attracted to experimental forms, at the feminist end of art (for example making her own paper out of pulp mixed with pubic hair, nail clippings, blood and urine). In about 1989, she began to make sculptures with found objects, such as kitchen utensils or pieces of furniture, transforming them from being protective and supportive into something threatening, by, for example, running an electric charge through them. Both *Crib VII* and *Incommunicado* are thus disturbing, but which is a better work of art?

Some may maintain that these two works of art cannot be compared: one is a modified found object and the other is a painting. But, whatever they are made of, the fact is that they both end up as images in one's mind, and their effect can be compared. *Incommunicado* gives one a nasty sensation when one realises how the cot has been tampered with, especially because one does not notice the thin wires at first, which makes the change more secretive and sinister, like a premeditated trap. One imagines a baby put into it and being sliced up by the thin wires. The impression is so horrible that one immediately snatches the baby up, metaphorically speaking, to save it from such suffering. Only someone with a very perverse mind would go on pressing the baby down in their imagination until you ended with a dozen, bloody baby slices. The impression the piece gives, then, is of an instrument of torture waiting to be used. Tate Modern, which bought the piece, informs us in its catalogue that *Incommunicado* is an image of a parental torturer, and beyond that of the 'parent' state abusing the 'citizen' child. It is an image, therefore, they claim, of political prisoners everywhere. The victim cannot communicate; not even its screams can be heard. That has an emotional appeal, certainly, but is this not emotionalism? Political prisoners are not mute babies; their effectiveness as communicators is often the key reason for their plight, neither do they usually rank among the world's innocents. In the end what does this work of art do for us? Does looking at it increase our sympathy for or our understanding of the plight of the countless political prisoners around the world in any way whatsoever? Or are you supposed to get the idea, pat

yourself and the artist on the back for both being politically correct, and walk on? What image do you take away with you — of a baby being sliced up? No, I suspect you take away what I did: a frisson of cruelty as you notice the stretched wires for the first time hidden in the comfort of the cot, which makes you turn away and look no more, thus ending the communication of this work of art. What has that to do with the suffering political prisoners in the world?

My guess is that the Tate's interpretation is wrong. *Incommunicado* is not a political statement at all, but a personal one, with its source perhaps not acknowledged, at least publicly, by its maker. My instinct is that the image is actually more about the parent than the child. It is a piece about not wanting a child at all, and perhaps for good reasons about not wanting to put it through all that that the parent went through. That would explain why the cot is institutional and looks like a combination of a prison and torture chamber — one not only for the baby, but also for the parent who will have to look after it. If it is, then one can look at the work with relief; you do not have to imagine a baby being sliced up because the work is about why there is never going to be one in the cot. The apologist for modern art would say that both these interpretations are valid, which just goes to prove that it is a great work of art. The trouble is that they cannot both be valid because they cancel each other out. You cannot look at *Incommunicado* simultaneously as a meditation on the feelings about not wanting a child and as a cry of anguish against the torture of political prisoners. Mona Hatoum is struggling to express some genuine feeling here, but, as with all *objet-trouvé* work, she is not fully in control of her medium; she cannot change it and, in the process, discover what she is really thinking and feeling. Hatoum has to make do with the cot she can find, rather than the one she could create in her mind.

Alexander Guy, by contrast, is totally in control of the image on his canvas, even the drips, which he can leave or paint over. He leaves them, I think, because he wants you to see that he has been painting with a degree of feeling and fury. Cool, calm painters calculate how much paint they need on their brush for the area they have to cover and work carefully so that there are no drips. Guy is not in that sort of mood, and he does not want you to think he is. *Crib VII* is not a painting of a real cot, but of one

101

that exists only in Guy's imagination. Nobody looking at this cot would imagine putting a baby in it; yet the spikes that line its base are no less uncomfortable for being unreal. In a way, they are more real, because they immediately strike one as having the force of psychological truth. One senses, just by looking at them, the complexity of parental feelings, the paybacks that parents cannot help secretly hoping for when they love their children. The cot, then, with its bars, becomes an image of a prison — the spikes the suffering parents cannot help but cause. And beneath this image of the cot, the artist has painted the word 'crib' — and so another dimension of meaning opens as we contemplate this picture. The cot becomes an image of religious love and indoctrination, which is totally consistent with and adds greater depth to all we have felt and sensed before.

Crib VII shines with the imaginative light of art, yet Alexander Guy's work is hardly known to anyone. *Incommunicado*, on the other hand, was bought by the Tate virtually as soon as it was made, and Mona Hatoum has had countless shows around the world from New York to Mexico, Ottawa to Jerusalem. Both Guy and Hatoum are serious in their intentions. The latter has a global reputation because her works fits into the accepted canon of modernism. The former is unknown, because he paints.

Alexander Guy's art emerged out of the strong tradition of painting, both abstract and figurative, that survived in smaller countries like Scotland much longer than in it did in the major urban centres. These schools — for years dismissed by art pundits as 'provincial' — will provide us with evidence of the survival of art during the era of the eclipse. There are artists such as the abstract painter Alan Davie who realised the Celtic potential in Pollock's early work. It was the strength of this local tradition that enabled John Bellany to spring, brushes flailing, from a tiny, east-coast fishing village, producing canvas after magnificent canvas inspired by the lives of its inhabitants, caught between the Bible on the one side and drink, sex and dancing on the other, set against the perilous backdrop of the sea. It never occurred to him to doubt that he was carrying on the tradition of Titian, Rembrandt and Poussin. The next generation, and the one after, were equally ambitious. Scotland is still rich in artists who can really paint and draw, such as Ken Currie and Jock McFadyen, Peter Howson and Steven Campbell. When Fionna Carlisle showed, with other young artists

from Edinburgh's entrepreneurial 369 Gallery, at the Chicago Art Fair in the early 1980s, she was surprised and delighted to come across so many painters working figuratively on a big scale, like herself. For her it was not a 'New Spirit' because the spirit had never been old. Her fellow exhibitor, the Scottish-trained, Chinese artist, Hock-Aun Teh, who had come to the West to escape bamboo and birds, paints explosive, sumptuous abstracts that combine Abstract Expressionism with the ancient spirit of Chinese calligraphy. The energy he releases in his art makes Hirst's spin paintings look merely mechanical.

This vigorous, local tradition has now been smothered by international conceptualism. In 1996, the Glasgow artist Douglas Gordon was awarded the Turner Prize for, among other efforts, slowing down the film *Psycho* so that it lasted for 24 hours. It still looked good, but then Hitchcock was a great artist and his every still counts. In 2002 Scotland's National Gallery of Modern Art commissioned Gordon, for an undisclosed sum, to make a permanent installation, consisting of lettering on to the gallery's walls the names of all the people he happens to remember meeting. The project is ongoing (he phones the name through when he thinks of someone). One only hopes that Gordon's memory fails before all the gallery's walls are filled with his utterly fatuous list. Gordon is very famous in the art world, and has shown in public art venues around the world, but his name is hardly known to people outside.

Ironically, at the same time as Gordon's reputation was blossoming, a young Scot, Jack Vettriano, was becoming one of the most genuinely popular painters in the world, though his name is not known in professional modern art circles, and no public gallery would give his work houseroom. Vettriano was born into a poor, coal-mining community, and got hooked on painting in his local art gallery in Kirkcaldy. Without ever going to art school he began producing pictures of upper-class couples dancing on wet, windswept beaches, dressed in 1940s' clothes, or girls un-popping suspenders in well-padded offices, all painted with a certain panache in the Scottish tradition, which soon ranked among the best-selling contemporary art prints ever, such was the appetite among the masses for the painted image. His pictures are mostly little better than erotic kitsch, but they are certainly no worse art than the productions of Douglas Gordon. Both

103

merit mentioning merely to illustrate that the gap between the art promoted by public art officials and that enjoyed by the public has never been wider. It is this gap that has to be bridged, by art that is both popular and profound.

As the eclipse passes, all recent artistic reputations will be reassessed. This will apply to those who have ridden high on the wave of the avant-garde, as well as to those who have doggedly resisted it, to the few figurative painters who went on working regardless of the general drift. By the 1980s, Robert Hughes considered that 'England now has a majority, if not a monopoly, of the best figurative artists in the world'. His 'formidable roster' included Francis Bacon, Leon Kossoff, Frank Auerbach, Lucian Freud and David Hockney. All had begun painting before the eclipse set in, and all except Hockney were originally represented by the Beaux Arts gallery, run by the redoubtable Helen Lessore. She was related by marriage to the English Impressionist Walter Sickert, who had himself studied in Whistler's studio and worked with Degas; and figurative painting was in her blood. She slept in a bed in the middle of her gallery because she liked to wake up in the morning and look at the art around her. There can be few tougher ordeals for a painting than to survive the early morning gaze of Helen Lessore. Her judgement was impressive, as time has proved, and her early support probably helped these artists survive the Cold War years.

Bacon did not have much of a problem, but then his art struck all the right notes for the avant-garde of its day, apart from not being abstract: it was shocking, instantly recognisable and full of angst. His work was and still is often upheld as proof that the art of painting is not dead, by people who conveniently forget that his reputation was established before this art's decline. Bacon's art, however, is a demonstration of painting's survival, not of its growth; it does not evince any evidence of development. Once his subject-matter and method — homoerotic, masochistic screams of pleasure and pain, as flesh and paint are manhandled, skewered, dripped and smeared, in the middle of a sea of silence — had evolved in the 1940s, it got locked into a pattern of repeats, some more passionate, some less so, as if a record had got stuck, and was still playing the same couple of bars at the end of the party, over and over again, when all the guests had either gone home or passed out. His *œuvre* will, in time, come to be seen as that of a *petit-maître* working in the footsteps of Picasso, who explored all these

dimensions of human experience, but so much more. Bacon was a one-idea artist, whose work ended in a cul-de-sac. He once said that 'art is a method of opening up areas of feeling rather than merely an illustration of an object …I would like my pictures to look as if a human being had passed between them, like a snail, leaving a trail of the human presence and memory trace of past events, as the snail leaves its slime'. The analogy is apposite: snails come out to feed when darkness falls.

Kossoff and Auerbach were more solemn and more ambitious; their paintings, portraits of friends or everyday scenes around their homes, exhibit real development over this period, but this was doggedly attained and often painfully slow — and it shows. They could only survive by battening down the hatches and virtually never leaving their studios. They had to try to ignore everything that was happening in art around them, and, one sometimes thinks, in life too. They could not, of course, at least not in art: they had to swim against the tide, and that, in itself, recognises the tide. At one stage, at the apogee of flatness, their paintings, particularly Auerbach's, got so thick that the paint was hardly able to dry. These works fitted the canon of modernism by turning painting into an object rather than an illusion. Yet the illusion of pictorial space was always there: without it the effusion of a face or a landscape could never have formed in the welter of brushstrokes left on the encrusted surface of what seem now to be pointless piles of paint. Thankfully, the work of both painters grew thinner, calmer and more painterly. These were two artists who managed to survive the eclipse, revealing poetry, as Sickert had done before them, in ordinary corners of London, even though tower blocks and tube stations had replaced the terraces and music halls of Sickert's beloved Camden Town. In Kossoff's paintings of swimming pools, packed with kids practising and splashing, you can not only see the riot of light dancing through the space, but also hear the kids screaming and smell the chlorine in the heavy air. This is paint at work again, creating that elixir of delight – just as, two centuries before, Constable caught the sunlight on the wind so that you could hear the leaves rustle and smell the new-mown hay. Kossoff, living when he did, only produced a small number of his paintings that break out into the light; as with Auerbach, so much of his work, worthy though it is, looks as though he was labouring in the dark.

Lucian Freud made more of the gloom. His art had an ingredient that made him acceptable to the contemporary avant-garde and which Auerbach's and Kossoff's both lack, though even as late as 1988 no museum in America could be found to take a touring show of Lucian Freud's paintings, not even one selected by Robert Hughes. A vein of nastiness runs through Freud's work, which leads him, for instance, to paint a naked man holding a rat, too close for anyone's comfort, to his splayed genitalia. Freud's early paintings were totally different from the ones for which he has now become famous. Even a lemon and a leaf, in an early painting by Freud, do not escape feelings of psychological intensity. They are by far his most rewarding works. After about 1950, this intellectual astringency and finesse of execution turned to flab, endless rolls of it, like old mattresses; the intriguing stream of disillusion reduced to a trickle of complacent cynicism, manifest in wilfully ugly paintwork, and a palette streaked with grey. It is not uncommon for artists to lose the inspiration of their youth, and Stanley Spencer was another highly original British artist who did the same. So, whether for internal or external reasons, a shadow fell across Freud's work too. At least, through dogged persistence, he kept the business of painting alive, even if his paintings do look as if it they have lain too long in a damp corner, under a stone.

By comparison, Hockney's work is pure sunshine; it is difficult to imagine an art more antithetical to Freud's. The finest expression of Hockney's considerable art manifests itself through line, not paint. His drawings can be superb: a freely held pencil or pen feeling its way across the flat surface of a sheet of paper indicating form and volume and space, yet always remaining on the surface, keeping its distance from the depth it is describing. Distance is the key to all of Hockney's best work. He never for one second loses his critical alertness. He would love to be in the swim, with his lovers in the pool, yet he is always on the sidelines, looking in. This accounts for the poignancy and tenderness of his work, and also for its endless playfulness. Hockney took to modernism — above all flatness — like a duck to water; it fulfilled an artistic and psychological need. Brushmarks, for Hockney, always lie on the surface of the painting, even when they are creating an illusion and that it why they cannot convey emotional depth. Hockney's work will come to be seen as a bridge between

the days before the eclipse when painting was pre-eminent, and its re-elevation afterwards — a brilliant light glowing on the distant horizon, if always on the edge. He has become so famous that he cannot be totally dismissed by those in the dark. Matthew Collings, the main spokesman for the Britpack artists, deigns to acknowledge Hockney's existence as that 'strange old loony figure', mistaking, with the arrogance of ignorance, the distant rays of the sun for moonshine.

The most exciting thing that will happen, however, as the eclipse passes, will be the emergence of new talent all around us. There are thousands of artists around the world who have gone on creating art because they have not been able to do anything else with their lives, but whose work has been totally obscured. Glorious new art, much of it modest, though still valid, some of it profound, will emerge from the gloom. Among these hidden delights will be the great art of our times. The tragedy is that we cannot yet see it. Public art galleries around the world show the same diet of narrow conceptualism, often by the same few, heavily promoted artists. Instead, their urgent task is to look freshly at the whole spectrum of visual creativity and begin the process of sifting this vast sea for those works of art that have lasting qualities. It is one of the most pernicious myths of modern art that we have discovered the great art of our age when, in fact, we have hardly begun to look for it. And there is no better place to start than in one's own backyard. It is surprising what one can find.

Take Tyneside, for example, in the north-east of England. It has just been graced with a new gallery, the Baltic, funded by the National Lottery, a huge converted grain warehouse on the banks of the river Tyne. Its opening show included a handful of works by just eight artists, all conceptual, ranging from a copulating couple drawn in strips of foot-wide, sticky black vinyl, a huge model of the Tyne Bridge made in Meccano (a rather superfluous effort since one can see the real one from the window), to a grainy video projection of a Russian space rocket being launched, and a set of gongs, which visitors can strike, inscribed with words such as 'blood' or 'semen'. No wonder I kept on overhearing that profound speculation whispered among the crowd: 'Is that all there is?' It is not all there is: Tyneside has, like all clusters of population around the world, its own battery of very different artists. These include the remarkable wood and

stone carver Fred Watson, a Morandi of the chisel. In 1989, he carved out of a solid block of marble a plastic bottle of cleaning fluid and one of wine, not with any comment on their contents, but just to show that beauty and proportion, a sense of stillness and lasting presence, can be revealed by art in the most ordinary things. Looking at this sculpture gives one a totally different sensation from looking at the real plastic bottles found, for example, in the work of the much-lauded artist Tony Cragg. In Fred Watson's sculptures, the dividing line between the space around his objects and the space he leaves within them is defined by the artist's loving touch — the point at which he stops. This is carving at its most contemplative, an extraordinary, isolated fight against the tide of contemporary art, just a few miles upstream from the Baltic, but a galaxy away in thought and feeling.

Twenty or so miles south of Watson's studio, another artist of exceptional tenacity worked in virtual obscurity until her recent death. Nerys Johnson was chronically crippled with arthritis from birth, never knowing what it felt like to run. Her output was remarkable; but as the disease took hold, her hands became too weak to grip a sheet of paper. She painted hand-size pictures of a tulip, or an iris, or just a leaf blade, with a strength of colour and design that makes them beam. They are essences of condensed exuberance, hundreds of them, all different, all radiant. On her death, in 2001, her executors offered the Tate a gift of seven tiny, though monumental paintings of single, pointed flax leaves, but they declined saying they were only of 'provincial' interest. Yet the Tate had just acquired their second painting by Ian Davenport. The contrast between Johnson's little paintings and Davenport's could not be more marked. Davenport dabs brush-loads at the top of his pictures and lets the paint run down; that is all. He usually restricts his colours to whites and greys. He calls them drab, and they are. Johnson's little paintings are glowing affirmations of the energy of life. By comparison with them, Davenport's work is revealed to be what it is: a tired, unthinking and unfeeling pictorial device.

Tyneside also boasts one of the most famous icons of modern art in Britain: Antony Gormley's *Angel of the North* (1998). It is one of the largest sculptures in the world, 20 metres high and 54 metres wide, sited on a hill overlooking one of Britain's main north–south trunk roads and railways.

Though erected in 1998, the *Angel of the North* is, actually, a nearly exact replica, though vastly inflated, of an earlier sculpture Gormley had made in 1990, which he called *A Case for an Angel*. It is literally a case, for Gormley's figures are always cases: they are not modelled but cast. To make his sculptures, Gormley strips naked and adopts a pose. He then gets an assistant to cover his bare body with plastic film patted over with wet clay. When dry, the clay is removed in sections and then used as moulds to cast a version of the sculptor's body, usually in lead. To make *A Case for an Angel* Gormley posed standing straight up with his legs together and arms outstretched, except that when he came to cast the body he had the wings of a miniature aeroplane welded on in place of his arms.

Gormley's work is partly about his failed spiritual aspirations: he studied Buddhist meditation in Sri Lanka for three years after leaving university. He explained *A Case for an Angel* in the following terms: 'It is an image of a being that might be more at home in the air, brought down to earth. On the other hand it is also an image of somebody who is fatally handicapped, who cannot pass through doors and is desperately burdened…the top of the wings…describe a kind of horizon beyond which you cannot see very much, and so you feel trapped and there is a sense of an invitation to assert yourself in the space against it'. Writ large, as a public statement, the *Angel of the North* says to all those travelling up from the South: I am deformed, earth-bound and you cannot come in here. This is not, I would imagine, a sentiment that would delight the city fathers of Tyneside. Gormley gets away with it because you can, in fact, read anything you like into his work, as with any mummy. Most who gather at its foot (it only has one, a single, ungainly lump, otherwise it would not be able to stand up) to have their photos taken, do not ask themselves what it means, but merely gawp at its colossal size. Standing beneath it, on the hillside, the perpetual drone of the traffic seems to be coming from within it, echoing around in its hollowness. When the *Angel of the North* was first proposed, a young reader of the *Gateshead Post* noticed that it bore a striking resemblance to a colossal statue designed by Albert Speer in 1935 (and destroyed during the war) of a young man standing with his arms outstretched and transformed into wings, celebrating the Luftwaffe. The association of the *Angel of the North* with Nazism seems to have been totally fortuitous, but strong.

Someone else spotted that the *Angel's* original wing profile was that of a Messerschmitt, the Nazi's fighter plane. Modifications were made, yet still the sense of oppression remains.

Just to the west of the *Angel of the North* are two more colossal sculptures, though the art world knows nothing about them. They are not as big as the *Angel*, yet they are monumental creations for all that. They were made in 1990, when Gormley was casting his original, fallen angel. David Kemp makes sculptures with found objects, in the manner of Picasso. *The Old Transformers* (1990) were commissioned by Sustrans, a charity that turned disused railways into cycle paths, to add interest to a track they were making that ran past the site of the Consett steelworks, once the largest in Europe, now razed to the ground. Nothing remains except an empty green field, stretching nearly to the horizon. Kemp visited the few remaining factories before they were finally demolished and salvaged vast, obsolete 200,000-volt heavy industrial transformer casings out of which he built two giant heads, *The Miner* (1990) and *The Iron Master* (1990). They stare over the vacant lot like the mysterious heads on Easter Island, magnificent and in mourning, precisely pertinent to their location, warmly human, and humorous, and deeply moving. Gormley replied to criticism of his modified body-cast by saying: 'There is nothing imperialist or triumphal about this. It concentrates feeling about the past in this place and also asks questions about the future'. Such vague abstractions mean nothing in relation to the image he has made, especially when one knows its origins. But they do have genuine resonance when applied to Kemp's poetic constructions. As one local wit put it: 'I've seen steelworkers and miners round here, but never a bloody angel'.

The achievements of Watson, Johnson and Kemp might rank small within the panoply of world art, yet they have so much more to offer than most of the art being promoted on the fashionable gallery circuits today. There are artists of similar stature all over the world whose work is being ignored simply because it does not fit into the current ideology. There are, however, no simple guidelines to help you identify a work of art, no list of criteria to follow. Instead you have to be able to expose your feelings and test the genuineness and depth of your response. There is no such thing as a work of art that works solely as an intellectual trigger, without

stimulating any emotion. If you do not genuinely feel something when looking at a work of art, but pretend you do, then the Emperor will soon be walking about naked. Increasing your experience of art is the best protection against being deceived by appearances. This is not a process of ticking off all the great aesthetic sights in the world, but of learning how to respond to each more fully and deeply. Looking at art in this way makes you more sensitive to the language of art. This opens whole new dimensions of enjoyment; you become alert to subtler nuances of meaning, and learn to appreciate the artistry in the telling. The purely formal aspects of art, its colours and shapes, lines and spaces, which are usually referred to as its abstract properties, then begin to be enjoyable for their own sake, as powerful conductors of feeling. When one starts to recognise this vocabulary one can then compare the merit of one work of art with another, and develop authoritative judgement. This will never be definitive, but it can be shared. And it will be within the critical atmosphere created by that shared judgement that the art of the future will emerge and grow.

I can identify many artists around the world whose work is imbued with the imaginative light that lifts what they make into the realm of art. I could mention Peter Angermann, who lives and works in Nuremberg. His beautiful, luminous landscapes are imbued with pain and express most vividly a polluted world. Yet, again and again, the intense feeling in them erupts into a ferocious, self-ridiculing laughter — black skeletons bathe in his radiant sea. His combination of gross cartoons with limpid beauty is deeply resonant of our times, exposed and celebrated for all to contemplate by an exceptional imagination and a brilliant sense of colour and tone. In Australia, one Aboriginal artist managed to adapt the traditional approach to painting, by far the greatest school of abstract art in our times, to express his feelings working as a labourer in Sydney. Robert Campbell Jr., who died at aged 49 in 1993, painted pictures of Aboriginal life in white men's cities. His deceptively simple, sumptuously coloured compositions pulse with life and suffering, exposing a racism that was not supposed to exist. In Papua New Guinea, the artist Matthias Kuage, a traditional highlander, is a local celebrity. He has decorated government buildings with his vivid depictions of modern life — local tribesmen fight to prevent an internationally owned mining company clearing their jungle, or

a woman hangs herself (an increasingly common tragedy) after being forced into an arranged marriage. His images derive their strength of design from ceremonial war shields, warpaint and costumes, intended to still the opposition with their visual force.

In Russia, during the bitter Brezhnev era, official artists (perhaps better referred to as art officials) ignored the work of Eduard Bersudsky; they thought he was just making children's toys. It was lucky for him that they did or he would not have survived. He had refused to join the Artists' Union — the only way to get a job in art or sell one's work. He took a job, instead, in the Parks Department, carving lions and zany characters for children's play areas. At home, in secret, Bersudsky carved sculptures which included moving figures; one, called *Tower of Babel* (1986), took him four years to carve from scraps of wood he found on his walks around Leningrad. The sculpture contains 53 little figures, all intent on their own tasks: Stalin is in the basement with his axe, and Lenin in his pulpit yelling at the crowd. All have the illusion of the importance of their role, yet everyone is being pulled by someone else's strings. This is not just a comment on the communist state but on the structure of all human societies. It is funny and mad, wonderful and almost unbearably sad. H. C. Westerman was not persecuted in America, and his work was shown in museums and galleries across the States, but he has still not been recognised as one of the great artists of his time. His entry into art via the Marine Corps, circus and joinery shop was eccentric to say the least, and he had to support himself as a janitor to get started. There is no merit in this *per se*, though it does indicate his determination, and demonstrates how art can be condensed out of life's experiences, not necessarily nurtured in a hothouse. No American artist of his generation that I know of embraced subject matter such as his *Death Ship U.S.S. Franklin Arising from an Oil Slick Sea* (1976), nor is any so formally astringent and endlessly inventive. His sculptures, always finely crafted, combine the toughness of David Smith with the poetry of Joseph Cornell. In an era when marketing has dominated the visual arts much more than it has the other arts, one of Westerman's handicaps was that he was incapable of repeating himself, as Andy Warhol did so endlessly and boringly. Since everything he made said something new, Westerman's art was simply too demanding.

112

In India, in 1958, Nek Chand Saini, a lowly transport official, began making a sculpture garden on wasteland at the edge of Chandigarh, the modern city in the Punjab designed by Le Corbusier. Nek Chand dreamed of creating a place where people would like to be. Forty years later, two million visitors a year come to wander through his terraces upon terraces of people and peacocks, elephants and ibises, and all manner of creatures arranged in their hundreds, rank upon rank, as if the gates of heaven had opened and one could meet again all one's friends in the human and animal kingdom. In Italy, Niki de Saint Phalle, created her own sculpture park, the Tarot Garden, at Garavicchio in the Maremma. It will in time come to rank as one of the great artistic sights of our age. She worked on it for twenty years from 1979. Nothing prepares you for the glinting, gloriously coloured, glazed sculptures, towering between the olive trees that also glisten in the Mediterranean sun. There is an Empress with a black face ringed with star-spangled blue hair, a deeper and more luminous blue than the sky above. There is a Magician with a silver hand raised solemnly to the heavens and a Tower of Babel with a collapsing roof; while Justice, with huge scales cupped in her great breasts, nurtures in her womb the struggling, intemperate, contorted figure of Injustice. This sculpture garden works on many levels, leading you down its paths, enchanting you with its sights, full of love and hope and mystery and sorrow in equal measure. Death, a golden lady with a red scythe, rides on a dark horse in the wood that skirts the hillside. Once caught in the web of this magical place, it is difficult to leave, until you must, as the sky darkens behind the raised silhouette of the woman in the silvery moon. Few works of art in our times are so joyous yet delve so deep.

The only one of these artists whose name is familiar on the contemporary art circuit is Niki de Saint Phalle, but she is known mostly for her early, angst-ridden work. Her later, brightly coloured sculptures, made after she had begun to come terms with the abuse she suffered as a child, have been generally ignored by the art world. Celebration has not been a feature of art in eclipse. By highlighting her work, and the other artists I have mentioned, I know I can be accused of giving too much emphasis to the naive tradition in art, epitomised by the work of Henri Rousseau. I make no apology for this — think how much poorer the National Gallery's

collection would be without Rousseau's great *Tiger in a Tropical Storm (Surprised!)* (1891), bought by that gallery in 1972, when it was still adding to the story of art. I am also ready to admit that I am particularly attracted at the moment to art that expresses joy, along with other emotions, as a reaction against the cynicism that so often greets one in the art of today. The Rousseaus of our times leap to one's attention, when one looks for them. Today's Cézannes will be harder to find; they will be working out of sight, in solitude.

Francis Davison, if not a Cézanne, was, at the very least, a John Sell Cotman of our era, an abstract artist of monastic rigour. It is difficult to describe the effect of looking at his large collages made out of torn and cut coloured papers. At times it is like going for a walk when the whole visual environment — the sky, the trees, the earth and the fields — collapses about one into an encompassing, luminous pattern. At others, the sensations are more internal and emotional, as if one's whole mind were on fire with reds and oranges and flaming gold. Always his feeling for space and tone is immaculate, and his images glow. He worked in almost total obscurity until I put on an exhibition of his work at the Hayward Gallery in London in 1983, the year before he died. Unbeknown to me, a young, aspirant artist called Damien Hirst was bowled over by the show and spent the next two years trying to emulate Davison's art, until he gave up. Hirst wrote later: 'Before I went to art school — on a trip to London — I saw a show at the Hayward Gallery of collages by an artist called Francis Davison that blew me away. [Tellingly, Hirst was not *shocked* by them.] When I moved to London a few years later, I was surprised to find out that nobody had heard of him, even though he'd had a big show in a major public gallery'. Hirst learnt his lesson, and made sure that that never happened to him. He decided he would be famous whatever he did. Julian Stallabrass quotes Hirst as saying as early as 1990, *before* he had made his big breakthrough: 'I can't wait to get into a position to make really bad art and get away with it. At the moment if I did certain things people would look at it, consider it and then say "fuck off". But after a while you can get away with things'. The artists of the eclipse have been getting away with things too long.

well said you old cynical bastard.

114

During the second half of the 20th century the concept of the modern avant-garde — the licensed uselessness of art — has been just as restrictive and destructive, in its way, as prescriptions about the social usefulness of art. This book does not say what the art of the future should be; it is up to artists to create that for us. Nor would one want to try, in any way, to restrict the language of art; it is also up to artists to choose the means that best express what they have to say. A work of art is not defined by how it is made, but by what it says — old-fashioned phrases such as 'art that holds the eye' still count. Paintings and sculptures are not automatically works of art because they use the great, traditional languages of art, any more than something automatically becomes a work of art just because it is placed in an art gallery. We now need to look beyond restrictive theories of art, beyond art galleries with their exclusive, radical agendas, beyond, even, artists themselves with their careful attention to career management, and focus all our attention, and every critical fibre we can muster, on to the works of art that are actually being produced today, wherever they come from and whoever makes them. The field in which great art grows needs to be broad and various. If you see a painting or drawing in a local exhibition that speaks to you, it is perfectly all right to take it home just because you like it, and it will give you much more satisfaction than any reproduction; art is nurtured by people who love it. It might be difficult to see clearly to begin with; in the midst of an eclipse it can seem as if the darkness will never end. But if you turn round, even just to the side, then you can sense the daylight re-emerging, barely noticeable at first, a thin light along the horizon. As the shadows lift, many reputations made during this time will come to seem monstrously over-inflated, and, as the darkness departs, we will discover many hidden treasures, totally overlooked until now. And everywhere art will begin to flower again.

Select Bibliography

Berger, John. *Ways of Seeing,* London and Harmondsworth, BBC, and Penguin Books, 1972.

Chadwick, Whitney. *Women, Art, and Society,* London, Thames and Hudson, 1990.

Collings, Matthew. *Blimey! From Bohemia to Britpop: the London Artworld from Francis Bacon to Damien Hirst,* Cambridge, 21 Publishing, 1997.

Crow, Thomas. *Modern Art in the Common Culture,* New Haven and London, Yale University Press, 1996.

Deitch, Jeffrey, et al. *Young Americans: New American Art in the Saatchi Collection,* London, Saatchi Gallery, 1996.

Elkins, James. *What Painting Is,* New York, Routledge, 1999.

Freeland, Cynthia A. *But is it Art?* Oxford, Oxford University Press, 2001.

Fuller, Peter. *Images of God: The Consolations of Lost Illusions,* London, Chatto & Windus, 1985.

Fuller, Peter. *Seeing through Berger,* London and Lexington, The Claridge Press, 1988.

Goldstein, Carl. *Teaching Art, Academies and Schools from Vasari to Albers,* Cambridge, Cambridge University Press, 1996.

Heinich, Nathalie. *The Glory of van Gogh, an Anthropology of Admiration* (trans. Paul Leduc Browne), Princeton, New Jersey, Princeton University Press, 1996.

Heron Patrick. *Painter as Critic: Selected Writings* (ed. Mel Gooding) London, Tate Gallery Publishing, 1998.

Hetherington, Paul (ed.). *Artists in the 1990s: their Education and Values,* London, Wimbledon School of Art in association with the Tate Gallery, 1994.

Hewison, Robert. *Future Tense, a New Art for the Nineties,* London, Methuen, 1990.

Hicks, Alistair. *New British Art in the Saatchi Collection,* London, Thames and Hudson, 1989.

Hobsbawm, Eric. *Behind the Times, the Decline and Fall of the Twentieth-Century Avant-Gardes*, London, Thames and Hudson, 1998.

Hopkins, David. *After Modern Art 1945–2000*, Oxford, Oxford University Press, 2000.

Hughes, Robert. *The Shock of the New. Art and the Century of Change*, London, BBC, 1980 (2nd edn., 1991).

Hummelen, Ijsbrand Hummelen and Dione Sille. *Modern Art: Who Cares?*, Amsterdam, Foundation for Conservation of Modern Art and the Netherlands Institute for Cultural Heritage, 1999.

Joachimides, Christos M., with Norman Rosenthal, Wieland Schmied, Georg Bussmann et al. *German Art in the Twentieth Century, Painting and Sculpture 1905–1985*, London and Munich, Prestel/Royal Academy, 1985.

Kent, Sarah, et al. *Shark Infested Waters – the Saatchi Collection of British Art in the 1990s*. London, Zwemmer, 1994.

Kent, Sarah, et al. *Young British Art: the Saatchi Decade*, London, Booth Clibborn Editions, 1999.

Kindersley, Lida Lopes Cardozo and Martin Gayford. *Apprentice*, Cambridge, The Cardozo Kindersley Workshop, 2003.

Kuspit, Donald. B. *The Dialect of Decadence, Between Advance and Decline in Art*, Stux Press, 1993 (repr. New York, Allworth Press, 2000).

Levin, Gail. *Edward Hopper – an Intimate Biography*, Berkeley and Los Angeles, University of California Press, 1995.

Murphy, Bernice et al. *Pictura Britannica, Art from Britain*, Sydney, Museum of Contemporary Art, 1997.

Ott, Robert and Al Hurwitz (eds.). *Art in Education: An International Perspective*, Pennsylvania, Pennsylvania State University Press, 1984.

Price, Dick. *The New Neurotic Realism*, London, Saatchi Gallery, 1998.

Read, Herbert. *Art and Society*, London and Toronto, William Heinemann, 1937.

Read, Herbert. *Education through Art*, London, Faber and Faber, 1943.

Reckitt, Helena and Peggy Phelan. *Art and Feminism*, London, Phaidon Press, 2001.

von Schaewen, Deidi and John Maizels. *Fantasy Worlds*, Cologne, Taschen, 1999.

Schjeldahl, Peter, et al. *Art of Our Time. The Saatchi Collection*, 4 vols., London, Lund Humphries, 1984.

Serota, Nicholas. *Experience or Interpretation, the Dilemma of Museums of Modern Art*, London, Thames and Hudson, 1996.

Sewell, Brian. *An Alphabet of Villains,* London, Bloomsbury Publishing, 1995.

Stallabrass, Julian. *High Art Lite, British Art in the 1990s*, London, Verso, 1999.

Taylor, Rod. *The Visual Arts in Education: Completing the Circle*, London, The Falmouth Press, 1992.

Varnedoe, Kirk and Adam Gopnik. *High and Low: Modern Art and Popular Culture*, New York, The Museum of Modern Art, 1991.

Varnedoe, Kirk and Pepe Karmel (eds.). *Jackson Pollock: New Approaches*, New York, The Museum of Modern Art, 1999.

Wolfe, Tom. *The Painted Word*, London, Swan Books/Transworld Publishers, 1989.

Zeldin, Theodore. *France 1848–1945* (vol. 11: Intellect, Taste and Anxiety), Oxford, Oxford University Press, 1977.

INDEX

Index by Christine Shuttleworth